THE PERFECT CITY

CREATING

THE NORTH AMERICAN

LANDSCAPE

*Consulting Editors*

Gregory Conniff, Bonnie Loyd,

Edward K. Muller, and David Schuyler

Published in cooperation

with the Center for American Places,

Harrisonburg, Virginia

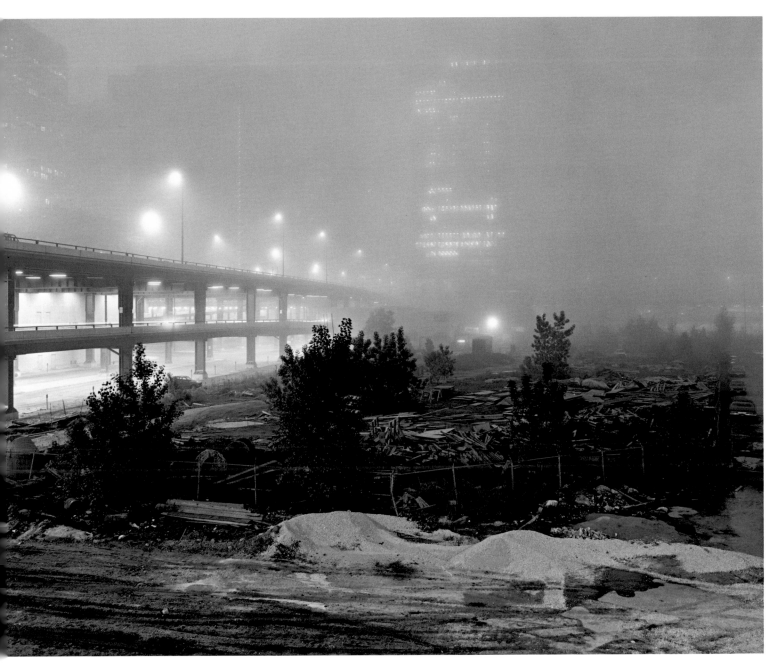

Bob Thall

# THE

# PERFECT

# CITY

with an Essay

by Peter Bacon Hales

The Johns Hopkins

University Press

Baltimore and London

© 1994 The Johns Hopkins University Press
All rights reserved. Published 1994
Printed in the United States of America on acid-free paper
03  02  01  00  99  98  97  96  95  94        5  4  3  2  1

The Johns Hopkins University Press
2715 North Charles Street
Baltimore, Maryland 21218-4319
The Johns Hopkins Press Ltd., London

Library of Congress Cataloging-in-Publication Data will be found
at the end of this book.
A catalog record for this book is available from the British Library.

*Frontispiece:*
Randolph Drive, east of Columbus Drive, view north, 1982

For my mother, Sylvia Thall,
and in memory of my father, Sidney Thall

# CONTENTS

THE PERFECT CITY

PETER BACON HALES

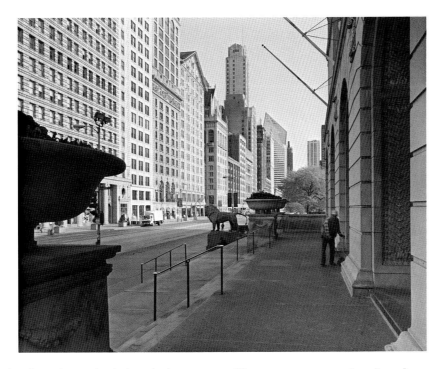

People who come to the American city bring their cameras. They come on vacation, for a long weekend, or on their way west or east, and they spend good time and money. They come because the city represents, and contains, something they value. They come to remember and to transmit. They want the city to be a part of their children's history as well as their own.

To read the popular press, you might think these people were mad. These days cities are symbols of the past, of a failed America, and being caught there proves you are a failure – too poor, too hopeless, too vicious, deranged, and genetically defective to get out.

Even the skyscraper centers have fallen on hard times in their bid for a better press. When everyone knew you had to leave the city to truly live, everyone also knew that to prove your mettle you had to work in the city. But the financial pages have discovered a new narrative of decline: since the early 1980s they have been telling us that city centers are overbuilt zones of irresponsible speculation. And lately it has gotten worse. In the battles to define and own the picture of the metropolis, in the common knowledge sold on the six o'clock news and

MICHIGAN AVENUE, VIEW NORTH FROM STEPS OF ART INSTITUTE
OF CHICAGO, 1992

in *USA Today*, all the big cities have found their downtowns transformed from happy capitalist enterprise zones to silent cemeteries of failure. You might wonder why capitalists invested in them and builders built them, and why at night they seem aglow with lights blinking on and off as maids and custodians move from floor to floor, office to office – offices that should be unleased and empty.

Knowing that cities go through these cycles in the public imagination doesn't really help. In the 1960s bookstore windows were full of books describing the corpus of the city (the corpse, really; on the dust jackets cities were shown as dead or dying bodies politic). After a few years that picture grew a bit shopworn. Cities came back. You'd read about city restaurants in the Sunday magazine. Architects returned as heroic figures: Philip Johnson, Helmut Jahn. Middle-class people living in bedroom communities they'd "fled" to back when cities were bad, argued about the buildings downtown: State of Illinois, Pennzoil Plaza, AT&T, Transamerica.

But that's over, again. By rights no one should be in the city these days – cities are now places for "concern." In the shaken, philosophical voices of the newscasters, in the hushed tones of *Wall Street Journal* editorials, in the call for caring found in newspapers edited and printed far from downtown, any fool can read the message: Stay away.

But Americans are resistant. They don't necessarily accept the angle of vision offered by the organs of culture. On the first Saturday in January, the parking lots around Chicago's Field Museum of Natural History are full of substantial cars with license plates from Iowa, Indiana, Wisconsin. In the crisp winter air families of four or five leave their cars, making sure the doors are locked (they're adventurous but pragmatic), and go over the crosswalk to the museum.

They are in a bit of a rush, too, not sure they have enough time – there's more on their list than will fit in the number of days before they return home. Waiting in line to try out the water baskets in the still-new Egypt exhibit, the parents talk about driving home a couple of days later, since the weather's so nice. The children, boisterous yet well behaved, dig in their parents' pockets for loose change to throw in the wishing well. They are having a good time.

Up on the second floor, fathers and sons wait for mothers and daughters to come out of the

restroom. Good-naturedly impatient, they feel the marble, illicitly rub the bronze busts that show the early twentieth-century concept of aborigines. The children explode out of the restrooms dragging things behind them. When they come to the city children bring their security objects. A little girl trails an improbably large blanket, gray with the grime every parent recognizes as a memento of excursions dauntlessly undertaken – trips to the Grand Canyon, to relatives, and to the city. Now the blanket makes her feel safe.

Her mother has her camera out, hanging from her wrist. Cameras these days are small and autofocus. They take great pictures, these miniature thirty-five-millimeter amateur cameras that sell for a hundred dollars or so, and they do everything for you. They are especially good for taking city pictures. With people in front of the Christmas tree, or the new house, or the old house, they have some trouble, because the autofocus sonar gets confused about what's important: The people? The house? The tree? With city pictures that's not a problem.

A window on the second floor of the Field Museum, in the geology section, frames a good city picture: bits of neoclassical facade, a nice stretch of parkland, and then the looming skyscrapers. But the best view is from the steps of the Art Institute. Everyone stands there for a moment or two, swiveling slowly to take in the sweep of urban civilization, from the stolid stability of the Hilton Hotel, past the richly detailed, even florid, oratory of monuments to the Chicago style, past the weighty gloom of the Cultural Center, to the gleaming vertical modernity of Illinois Center to the north. Above and behind this city wall other tall structures crowd the pale blue sky, filigreed with pale clouds, inexhaustible, sublime.

Having seen the prospect, people want to record it. They raise their cameras and discover that the wall can't be contained in a single picture. They aspire to the vast banquet cameras of a century ago, whose glass-plate negatives took in twenty-two or thirty inches of horizontal axis. With their one-touch sure-shot cameras, they have to choose a piece that will somehow suggest the experience of the whole. Usually they aim to the north, where they can balance the sublime civility of the Wall with the picturesque civility of the park that recedes into the gleaming, Oz-like structures of Illinois Center.

This is what they came to see, came from the Middle West to Chicago, or from the North-

west to Seattle, or from the Southeast to Atlanta: the museum of the city, specimen case for modern Western civilization. Though they may not know it, the picture in front of them is a collage of symbols in a long debate over the components of the proper city. The lakefront (or in other cities, the bay, the fen, the river, the prairie's edge) signified what the city was not and yet what it serviced, how it connected to what it was not. The park too (*rus in urbe*, Frederick Law Olmsted called it) was a necessary rejuvenating counterpart to the city's essence – its energy, its relentlessly human-made core, seat of the culture of money and trade and progress – to be found in its tall buildings. From the decades after the Civil War, when a variety of economic, technological, and demographic factors prompted the boom in buildings more than four stories high, skyscrapers drew everyone's attention. They signaled progress and modernity, but they also signified the particular ambition the city symbolized – to reach the sky, to test the limits, to create perfection in human terms, to mold the environment rather than be molded by it.

But this late nineteenth-century idea of the city as museum was not limited to the realms of serious architecture and florid oratory. Most Americans learned how to look at the city through a more universal lens – their grade-school primers. City lessons taught in the schoolroom reach back into the nineteenth century, but they changed, became more potent, in the Progressive Era that accompanied the modern American city. As John Dewey's progressive system started to change American education, the grinding routines of memorized lessons and declaimed speeches, described so well in *Tom Sawyer* and *Huckleberry Finn*, were replaced by little lessons in real life. Along with "A Visit to the Farm," there were "Glimpses of the City" and "John and Jane's Neighborhood." In these stories children found the urban environment a rich source of necessary human lore, because the books' authors and editors understood that the city was a potent symbol of American civilization.

As late as the 1950s, when everyone was growing up in the suburbs (everyone of importance, that is – with power, money, and a future), social-studies books kept the format. Even the second- and third-grade primers described trips to the fruit-and-vegetable market of some

unnamed American metropolis. The Golden Books series included a whole shelf of texts celebrating the noise, the energy, the polyglot population of the city. When parents read their children *Mike Mulligan and His Steam Shovel*, first published in 1939 and still in print today, the duality of city energy and rural rejuvenation entered the imaginations of four-year-olds.

As children grew older, the textbook pilgrimage to the city was replaced by a pilgrimage more noisy and chaotic: the field trip. From Guilford, Connecticut, from Penn Hills, Pennsylvania, from Ojai, California, from Morton Grove, Illinois, twice a year buses left the school parking lots, headed for the epicenters of American civilization. They followed the prescribed route along the new superhighways that had allowed the previous generation to leave the city, through the crumbling neighborhoods, to the bustling city core where commerce and civilization met. Once they arrived the buses idled in the parks (Central Park, Golden Gate Park, Grant Park) while the children erupted onto the sidewalks, carrying their sack lunches, to be ushered into new zones of culture.

Those children of the 1950s are parents now. And when they think of travel that broadens, of expanding their children's horizons, of all the clichés parents reconstitute from their own pasts, the city is central, one of the icons. There is the West. There is the seashore. There is the farm. There is the forest. And there is the city.

Mostly they still come to the museums. Museums house civilization in a form manageable for people who have a couple of days and need to keep eight-year-olds entertained. You may think a 1906 diorama of bighorn sheep on a concrete mountain covered with cotton snow in front of a painted backdrop inside a glass-and-wood case is inauthentic and deadly. Molly Hales, age eight, does not think so. She is willing to push her parents aside and jostle her brother to get up close. She and the other kids argue about the best parts of the best displays, and they press their hands and faces on the glass no matter what you tell them, for part of the experience is recognizing the invisible barrier between the self and the object of desire.

Parents like the museums because they are sites of learning and repositories of knowledge. What we learned from dimly conceived ancestors, and took to be truth, we pass along to

children who will too soon be grown and gone from our influence. Parents discover that the basic values haven't changed (at least not much). They are less attentive to the small things, having seen them many times and needing only to remember; their gazes now rise to the columns and windows and the spaces that are the province of grown-ups – of people whose appreciation of architecture has been awakened by mortgages, by church building funds, by an adult's recognition that the classical facade on the bank of home does indeed convey security in the face of fluctuating interest rates and finance crises.

Maybe it is no surprise that the most popular tourist cities have cores that replicate the architecture of museums: neoclassical, Renaissance revival, Gothic revival, interspersed with modernist structures that look much like the pieces in the sculpture gardens or twentieth-century wings of the art museums. The cities look this way because they are the historical aggregate of individual icons of display. When they were new, the facades of downtown buildings weren't simply stylish; each element conveyed some symbolism for architect and owner. It is the job of architectural historians to reclaim their significance from the process of forgetting, of melding and mistaking, that eventually patinates the sharply delineated messages of the moment. But accurate history is not what people come to the city to find, nor is it the way they learn from the city.

Partly from lack of money, partly through an exhaustion of hubris, most city planners are no longer quite so busy trying to make brand new museums out of their downtowns (though most every city in the United States now has its scaled-down nostalgia mall). They seem to have discovered that the city has spontaneously become a museum on its own – a lucrative one, too. After all, that's why people bring their cameras to the city. The planners need not be servants to some ideal urban order: they control the view, define the boundaries, determine the proper vantage points.

We may think of tourists as potential markets, as possible investors, as aspiring residents. But that misses the power of urban aesthetics or the underlying law (drivers of urban tour bus-

es know it, and so do their employers) that urbanity is perceived through the senses, not the intellect.

To an urban planner with a Swiss disposition, visitors may seem annoyingly aimless, without plan, motivated by fear and ignorance rather than curiosity or intelligence. But if you listen to them, if you ask what they're up to, you find out something different. They've come to take the city's picture, to find the spots where the city view can be seen, and to wander for a time in that view.

In the United States, some cities are better than others as museums and as objects of view. For me the best are San Francisco and Chicago – they're about as close as you can get to the Emerald City. Both have their blends of exotica: Chinatown, Greektown, Maxwell Street, the Mission. Both have their own forms of transportation – not Oz's Horse of a Different Color, but the cable car and the elevated train. San Francisco has the advantage here; the cable cars climb the hills, and on the heights you can get off and see everything: shoreline, bay, islands, ocean, the mainland you came from and will return to, enlightened. The preternaturally clear light of the city on a sunny day (when there is one) etches everything. In a single frame you can get the whole thing, even the cable car.

In Chicago the elevated is not the way to go. If you want the high-angle, bird's-eye view, you stand in line and ride the elevator to the top of the Sears Tower or the Hancock Building and take pictures from the observation deck. It's not the same, though. The intimacy of the hill, the sense of security that comes from seeing how you got to the picture's vantage point, is lost when you shoot from the Sears Tower. In its place is a dispassionate cartographer's clarity.

But from the el you see pictures, too. Most people find them in the summer, on their way to Wrigley Field for a Cubs baseball game. These are visions of the urban picturesque – of kitchens and porches and backyards seen from the train windows. Coming back from a double-header or on the way to a night game, the light from the flats is warmly yellow, as if painted in tempera. A gesture seen at that moment (a women taking the salt from the shelf, a man carrying

a baby on his shoulders) is rich with a painful familiarity that reminds visitors of the foregone intimacy that makes for homesickness. We can't photograph these scenes, for to do so would violate what we ourselves love most privately.

Anyway, the flat terrain surrounding Chicago calls for a different photograph – not the high angle from the Sears Tower or the poignant voyeurism of the el at sunset. It calls for something few American cities have: true vantage points. In San Francisco the hills get in the way. In New York City you're never in quite the right place. From Central Park, from the Battery, from the excursion boats that circle Manhattan, you may get a picture close to the ideal found in Chicago, but you can never include the Empire State Building, the Flatiron, the World Trade Center, and the IBM Building all in one frame. Manhattan always bleeds off the edges.

In Chicago that's not so. From almost any entryway on a clear day, you can encompass the entire core in a focused glance. As you ride in from O'Hare Airport on the expressway, the Hancock defines one edge, the Sears the other. By Ohio Street the rectangle has stretched to become a panorama. Driving in from the south (as most people with cars do) the view is as good – just reversed. Probably the best views, though, appear on Lake Shore Drive as you travel in from the skyway that leads from Indiana, from Michigan, from Ohio and the East.

And then there is the Chicago River. Even from inside the city core you can encapsulate it. If you stand at the corner of State Street and Wacker Drive and photograph across the river, you'll get Marina Towers, architect Bertrand Goldberg's Rube Goldberg fantasy of exuberant midwestern modernism. You'll get the Gothic spires of the Wrigley Building and the Tribune Tower, each defined by odd sites and irregular spaces. Or you can aim south, capturing restored neoclassicism and New York postmodern and even Helmut Jahn's portly glass State of Illinois Building.

But the river's not the true source of Chicago's visionary advantage. Follow a group of foreigners (Germans, Australians, Japanese) on an architecture tour. Up from the Federal Center, opposite the Mies-inspired Daley Plaza with its Picasso, there's a big hole – an entire block emptied of buildings, awaiting development. This confuses the visitors. Was this gap caused by

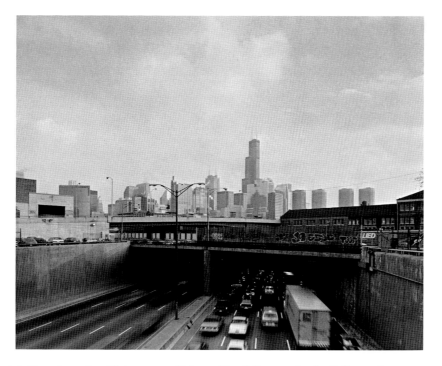

slum removal, they ask? No – just the Chicago tradition of building and rebuilding, of spaces left empty for a season or a decade, holes opened up in the skin of the city, exposing secrets.

Stand at the far corner of one of these temporary zones, and you see the space as not an absence but a presence – as a device for display, a vast urban diorama opened up by bulldozers. From this vantage point the city is a museum in a different way. Here the aesthetic is not urban sublime but urban picturesque.

This is the vantage point for a different type of city viewing. Not awe, but surprise and delight are the responses to the urban picturesque. If the urban sublime has its ideal photograph (the wall as we saw it from the steps of the Art Institute), the urban picturesque requires a series of photographs that record the delectation of the urban walk. It's not a postcard but an album. You hold one example in your hand, at this very moment.

You might think you need a tour guide for this walk – say, Ira Bach's *Chicago's Famous Buildings*. But books like that aren't really much use – they begin from an inappropriate

mythology. Most people look over Bach's text in the taxicab or on the el or use it to put themselves to sleep in a strange room with a bed too virtuously firm, with lights too bright and the television in an awkward place.

Bach's descriptions are all wrong for the urban picturesque. He wants you to stand smack in front of each building, seeing it from an angle possible only using the most sophisticated architectural cameras and lenses. Bach wants to make the city a collection of sublime objects – to reindividuate the buildings that have blended so marvelously into the wall and the walk. His maps, demarcating buildings within a grid, present the urban aesthetic as rather grimly puritanical, all right angles and obligatory lessons. You stand in front of Bach's buildings, holding his book, the way you stand in line at a Presbyterian worship service, contemplating your sins and waiting for Communion – grape juice and a stale cracker. Like the difference between Communion and communion, between the obligatory ritual and the experience of oneness, there is a vast distinction: there's standing in front of the Monadnock with Bach's book, and then there's coming up from the subway to find the Monadnock on your left, gloomily sooty and magnificent. Bach implies that you need to learn before experiencing. His appreciation is all schoolroom, no schoolyard.

Most people are willing to do their lessons, but that is only part of the fluid experience that dominates city viewing. Out on the street, the eyes have it. They devour the spaces, pace omnipotently up and down the mullions in Ludwig Mies van der Rohe's buildings, trace the filigree of Louis Sullivan's Carson Pirie Scott Building, or play with the distorted perspective in architect Tom Beeby's new public library. Each of these buildings is seen framed by vacant spaces. You can get really close to them without much embarrassment. But you can also stand far enough back to see their tops. You can rarely do that in New York City; Philip Johnson's Chippendale top to the AT&T Building is infamous because the view of it is always blocked from the street. In San Francisco, in Chicago, you get the whole scene.

To stand awed before one building is the urban sublime as dour teachers would like it to be. But city viewing isn't necessarily a programmatic movement from monument to monu-

ment. It's often a more complex and indeterminate process, irregular and surprising. Neither the tour nor the book defines this type of experience. It's the act of wandering – of *sauntering*, as Henry David Thoreau would have it. It's remarkably similar to the way nineteenth-century Americans learned to experience the wilderness when tourism in the American West became popular for the well-to-do after the Civil War. In both cases there are pauses for sublimity – you can see people (children and photographers are less embarrassed about it) standing on the sidewalks in peculiar angles of repose before the tallest, the widest, the most bizarre. And there are moments devoted to the unexpected, the small-scale, secular, and vernacular – schoolchildren's murals on the plywood construction barriers, or mannequins piled in the window of a store just gone out of business.

But in the end it's the accretion of experiences that people carry away from the museum of the city. They walk from the Jackson Street subway stop past the Monadnock, up to the Federal Center, with its Calder stabile a far less interesting piece of sculpture than either the massive blackened old building or the artfully rusting Lego block of the modernist Federal Center. They walk past the First National Plaza, with its bad mosaic by Chagall, to the Daley Plaza, another Miesien sculpture, with its Picasso turned into a take-off platform for "thrashers" – virtuoso skateboarders with an attitude. Across the street is that wonderful hole – Block 37 – and perched within it a bizarre piece of a building, the art deco facade of the Commonwealth Edison substation. Behind it they can see the pillars of the lakefront high-rises set against the sky above Lake Michigan. They cut across the plaza from Dearborn to Clark Street, and there's the State of Illinois Building. Its atrium is a cavern turned inside out, its elevators an amusement park ride. Then it's up to the Chicago River; across to Michigan Avenue, from the Hancock down to the Art Institute; over to State Street; down to Beeby's wryly historicist Harold Washington Library. The sequence isn't programmed. It could take three days to cover the entire route – some of it on foot, some by car, some late at night by horse-drawn carriage. But the city still carries its messages: about grandiose human ambition; about the heroic molding of an environment; about the integration of past and present; about respect for order,

capital, principles. And the small deflations – the skateboarders and the denizens of Walgreens and the signs announcing bankruptcies – these leaven the weighty conservatism of the city wall.

After three days or a week, people who come to the city come to the end of their plans, and they return home, following the interstates that took them out to the suburbs and "edge cities" a generation or two ago, leaving the city a beautiful museum. They've filled their film, and when they're home, they'll mount the pictures in photo albums. The city will have a page or two to itself, before or after the mountains' sublimity or the seaside's picturesque pleasures, representing nature – wild, semiwild, or parklike. The city will represent (as it always has) civilization, an ecology of museums that is itself a museum, historicizing, monumentalizing, giving weighty pause to aspiration and accident alike. The museum of the city.

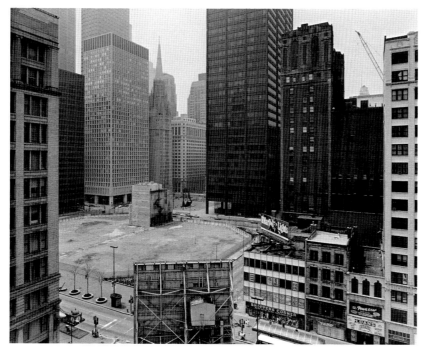

It was during the Christmas shopping season of 1991 that ice skaters first appeared in the three-acre vacancy of Block 37 in downtown Chicago. The sight was a relief to the window dressers at Marshall Field's department store, where the new Christmas displays, with their ingenious mechanical, electronic, and decorative fancies, had recently been unveiled. Field's windows are a major attraction of downtown Chicago's State Street retail zone. When the displays are new and elaborate, they are joined by old-time chestnut and pretzel vendors, bebop Christmas quartets, Appalachian hammer dulcimer virtuosos, puppeteers, guitarists, and equestrian police cantering along the street. The picturesque mix draws crowds from the suburbs and new cities that ring Chicago, as well as tourists who come from far greater distances, to see the city at its most Dickensian. In good years the downtown becomes a vital retail zone, besting the suburban malls, if only for these weeks.

But for the past few years the Christmas windows at Field's had looked out across bus-infested State Street at a symbol of civic disaster, an international landmark commemorating

BLOCK 37, VIEW SOUTHWEST FROM RANDOLPH STREET AND WABASH
AVENUE, 1991

(says the conventional wisdom) the inexorable decline of downtowns. With its pitiful saplings planted to hide the plywood wall that always marks the first years of urban renewal gone sour, Block 37 seemed, to recession-struck retailers and a city government with an image problem, to be as dour and admonitory as the Ghost of Christmas Yet to Come. And so, with the usual fanfare, the developers and the city announced that the lot would become a public skating rink. The picture they presented at press conferences and in press releases drew unmistakably on Manhattan's fabled Rockefeller Center rink, long embedded in American consciousness as an archetype of the urban picturesque. Happy shoppers crowding the street, graceful women on the ice: most people remember the scene, they think, from *Miracle on Thirty-fourth Street* or *White Christmas*, though more probably it comes from countless ads, first in newspapers and magazines, then on television. To convert urban decay to shoppers' splendor with one spectacular wave of the public relations wand must have seemed like a secular miracle.

This wasn't the first attempt to remake Block 37 from a visible catastrophe into a nice little video bite. The summer of 1991 had seen a tent community (one vast tent and seven smaller ones) rise in the same spot, filled with inner-city youngsters "turning their experiences into art," in the words of the *New York Times*. Lois Weisberg, Chicago's commissioner of cultural affairs, told reporters that summer that "we thought about ice-skating rinks, but the developer and our office wanted to do something meaningful." The summer program had been particularly photogenic, with its earnest ghetto sculptors and painters hard at work on masks and statues, while the tents billowed in the winds concentrated by the canyons of skyscrapers surrounding Block 37.

Both pictures – art and ice – stood (like the plywood walls and the sad saplings around Block 37) to hide that third, darker scenario of a city in decline, doomed by its age, by its unfortunate habit of attracting "the culturally disadvantaged" and the "underemployed," by its concentration of greedy unions, greedy politicians, greedy civil servants bleeding the color out of the urban fabric and leaving it tattered and disintegrating. Outside the doomed city centers (so the scenario went) were the counter communities, the vital new "edge cities" full of busy,

homogeneous workers grateful to their employers for rescuing them from rubbing elbows with the dangerous and the undesirable in surroundings redolent of decay. This was the picture the *Times* evoked when its business writer called Block 37 a project doomed by "financing dried up and tenants hard to find," "forlorn," "a symbol of Chicago's deflated building boom." It doubtless was also the picture held by figures in the city administration and by representatives of FJV Ventures, the developers of Block 37. Both groups had scrambled since the previous summer to disperse the aura of failure hovering over Block 37, and they had spent good capital – cash and political – to do so.

But the Block 37 that image artists fought over did not appear out of whole cloth in 1991. It had a history of contesting images.

Traditional urban historians rarely look at these pictures. They strive to see *through* them to the events that occur behind the scenes, to the meetings where contracts are negotiated and real urban planners and developers and all the other important parties in any such complex and economically significant venture sit down and negotiate. This is where the *reality* of city life is decided, these traditionalists might argue. Mark Miller, editor of the prestigious and relentlessly hard-nosed *Crain's Chicago Business* and a business news correspondent for National Public Radio, summed up the position when, at a conference of urban planners, historians, and architects, he dismissed the city image as the realm of "soft facts": "We deal in *hard facts*," he told his audience. His contemptuous tone made clear what his listeners already knew – that behind the scenes, invisible to all but the cognoscenti, an economic calculus drives the decisions that make cities the way they are. In the rooms where the spreadsheets are tabulated and the "hard facts" negotiated, attendance is by invitation only.

Most of us are not invited. We find out about decisions after they've been translated into public declarations. We view the city's workings from a distance, where "soft facts" – pictures of the city – dominate. The drama takes place in front of the scenery, controlled not by negotiators and professional planners but by the writers of press releases, and by the speech writers for politicians who weave those pictures into urban myths. *That* is where the moral

tone of the city is set, where the city becomes good or bad, inviting or dangerous, sympathetic or corrupt.

What's compelling about Chicago's Block 37 is how well it has served this allegorical function, how deftly it has come to reflect the changing ways the city has *meant* over several decades.

A proper picture history of Block 37 would have to reach back in time to encompass the public and private debates concerning urban redevelopment, its funding and its function. But for our purpose even a small sample reveals the battle for the city's image. We might start with an establishing shot – a panorama of the post-World War II years, when phrases like "slum clearance" and "urban renewal" held sway. This paradigm dominated as late as the 1970s, and some of the earliest press releases on Block 37 reflect its influence. Aging and useless, the block was "an eyesore," a break in the line of gleaming modernistic buildings that urban planners envisioned for the Loop west of State Street. Seen from the Apollonian heights of the ideal city plan in the Sunday supplements or a commentary in the business section of the Chicago *Tribune* or a gleaming pamphlet from the Greater State Street Council, Block 37 was prime commercial land languishing under a hodgepodge of aging, outmoded buildings – low in density, low in height, low in tax revenue, low in prestige.

The press releases were unequivocal. They didn't see life in the place – they saw death. Its movie houses showed kung fu flicks and Russ Meyer sexploitation movies and slash films to teenage truants who, after the movie ended, would wander over to the video arcades to waste more time before intimidating some earnest, God-fearing family just in from Iowa. The solution was simple, elegant, and right in line with the aggrandized dreams of urban planners still unaware that the waning of the Great Society had brought a precipitous decline in the power and status granted their profession. It was time for urban renewal, declared the editorials: condemn the properties; buy them up; tear the buildings down; sell the land to some right-thinking team of capitalist visionaries who can come up a plan that mixes grandeur and good sense, high modernity and taxable property.

By the early 1980s, proponents of this picture of the city could point to the good work of

Chicago's Commercial District Development Commission and its North Loop Redevelopment Plan, the latest in a long string of controversial plans to "save" the area. As the commission's publicists presented their picture, the plan would mix the two elements of the museum of the city – the modernist ideal of the urban sublime and the nostalgic ideal of the urban picturesque – by designating certain historic buildings as landmarks (not to be touched) and the rest as real estate.

Block 37 was crucial to the North Loop Redevelopment Plan: it lay at the heart of the Loop. To the west was the wall of buildings that the plan deemed essential to a proper downtown: high modernism and postmodernism, from the soon to be built State of Illinois Building through the Daley Center and southward past the First National Bank Building to the Federal Center. To the east were the famous old buildings: Louis Sullivan's Carson Pirie Scott department store; Marshall Field's; the restoration-destined Chicago Theater. To the north was the eradicable embarrassment of the Greyhound and Trailways bus terminals. They would soon be gone, promised proponents of the North Loop Plan

In the flurry of public events surrounding the release of the plan, an urban myth took shape. Block 37 could be, would be, the transition between the past and the future. To read the press reports, Block 37 had only one bona fide significant building, but it was a beauty: the McCarthy Building, certified by champions of the plan as the first downtown Loop building ever designed by a genuine architect, and a grandfather figure to the so-called Chicago school of architecture. Everything else was riffraff.

(This description of Chicago's architectural history was, and remains, one of the most controversial parts of the public picture, and one of the most interesting. At various moments, and for various people, the McCarthy rose and fell in significance, and its architect rose and fell too. So also with a number of the other buildings noticeably absent from the public version of the plan. Clinton Warren's Unity Building, for example, was a genuine "Chicago school" building. The Commonwealth Edison substation, not mentioned in the press reports, but, bizarrely, the last building left standing on the block, was designed by one of Chicago's most important architectural firms, Holabird and Root.)

And so one of the first official acts of the Commercial District Development Commission was to call for bids from developers and architects to create a "mixed-use," mixed-symbolism buffer between the urban picturesque and the high modern sublime. The astonishing rapidity with which hotshot developers came up with bids and proposals suggests that this public sequence was the culmination of another set of events in which the inner circle of city powers had already achieved harmony on how to save the city. Two bids had arrived by May 1983: one was a sure winner, and it was rapidly anointed. It brought together three of the city's most powerful real estate conglomerates. JMB Realty was a Chicago legend, two college buddies whose partnership had become one of the largest real estate forces in the world, buying up and developing multibillion-dollar projects, then selling pieces to gold-plated investors: pension funds, banks, big-name securities firms. And JMB had a reputation as one of the best of the mixed-use urban redevelopers; it had stakes in Boston's Faneuil Hall and Copley Place projects and New York City's South Street Seaport.

The other two firms were just as gilt-edged, if not quite so international in scope. The Levy Organization was a restaurant and food service conglomerate that had been branching out into urban development with great success. And Metropolitan Structures had garnered one of the city's most grandiose redevelopment projects since the Great Fire: Illinois Center, which was at that moment filling the hole between Michigan Avenue and the lake with a string of big buildings reeking of money and status.

The plan also had two quieter participants. One was the architect Helmut Jahn, whose firm of Murphy, Jahn was as hot as hot could be and located right in Chicago, symbol of the new postmodern Chicago school. Jahn had drawn a bold though rather imprecise picture of Block 37's future, including a rendering that would regularly appear, often modified, in the newspapers over the next decade. The other was Harold Washington, Chicago's new mayor, who had as one of his first and most dedicated campaign contributors Bernard Weissbourd, chairman of Metropolitan Structures.

From the first there was some confusion over what Block 37 would finally look like. In un-

veiling the proposal, the developers (now known as FJV Venture) had described it as historic preservation on the order of Boston' Faneuil Hall and Milan's Galleria. But the pictures Jahn was putting out looked more like big-city real estate. First the McCarthy, formally designated a historic landmark in 1984, was to be incorporated in the facade. Then in the fall of 1985 the developers announced there had been a sad mistake: the McCarthy was in the wrong place, interfering with the entry ramp for a parking garage, and it would have to go.

Most anyone could have told FJV that its argument was inopportune. It wasn't the violation of covenant that was so bad; it wasn't the abrupt change of the picture from historic preservation to successful development; it wasn't even the rather frank public blackmail implicit in the new proposal. It was the idea of the urban picturesque replaced by a parking garage.

The conflict escalated quickly. While the developers assured everyone that things were still in the "negotiating" stage, organized forces for the urban picturesque were releasing their own press packets, holding their own press conferences, sending out representatives with slide trays and speeches declaring that destruction of the McCarthy would prove that "the landmark process is a farce, and no building so designated is safe from capricious development."

This counterimage was successful. By the end of 1986 FJV was unveiling a new plan, to move the McCarthy Building from one corner of the block to its kitty-corner opposite, so that State Street could be maintained as the facade of the past while Dearborn to the west would be the home of the future. On the strength of this, the city began to sell its first set of bonds to raise the cash to buy the land.

In February 1987 FJV had a new idea: tear down the McCarthy and provide compensatory contributions toward restoring the "more significant" Reliance Building nearby – but not on – Block 37. This provoked a new blizzard of press packets from "conservation" and "preservation" groups, who argued that the entire covenant of the North Loop Redevelopment Plan had been based on the notion that to win the bid you had to agree to save history from

progress. But this time the picture of progress won out over the picture of restored history. In April the city signed a formal contract with FJV.

Some may think that contract was more important than the documents I have been tracing – the press releases and the reports of press conferences and the commentaries and notes in the business and real estate sections of the newspapers. After all, it enshrined in legalese the preservation of the McCarthy; it called for FJV to pony up $1.2 million in real cash; it set the price of the land at $12.5 million, the value determined back in 1983 when the first call for bids had gone out. If you wanted security, it was there in the contract – the McCarthy was saved. If you wanted evidence of perfidy, it was there as well, for the city seemed to be giving FJV something over $20 million, the spread between the developers' cost to buy the land from the city and the current estimate of condemnation expenses to the Redevelopment Agency.

In one picture this sum represented a gift, even a bribe; in another it was "an inducement." In either case it would increase in value precipitously over the next few years, as condemnation procedures reached their conclusion and estimates turned to certified checks. And the proposal to save the McCarthy Building would turn out to be "technically impossible" (as an official tactfully put it), replaced by a developer contribution of $4 million to a general kitty for preservation. By fall 1989 the Chicago *Tribune* was celebrating the imminent arrival of a $400 million "megastructure" at "the epicenter . . . of the city's twelve-year, billion-dollar campaign against raunch and honkytonk." And Mayor Richard Daley, who succeeded after Harold Washington died, was calling it "a milestone in one of the largest urban renewal projects in the nation . . . a key to the revitalization of State Street."

This was a winning picture. After decades of struggle, a persuasive narrative of urban renewal had finally emerged, with Block 37 at its center. The image was attractive to the editorial and business writers of local and national newspapers and magazines, and it was persuasive to their audiences as well. But it did not win everyone over. Dependent on a view of the city as seen from above, it clashed with the picture of city life held by urbanites who prided themselves on their savvy, their street smarts.

Down on the street, Block 37 before the purges was a delight, a visual miracle. It contained everything the cool homogeneity of the city wall lacked – raunch and funk, noise and a bit of terror. On the Daley Plaza side there was the McCarthy Building and, north of it, the marvelous, brutal, streamlined 1929 Commonwealth Edison substation. Rounding out the other three sides were the grimy remnants of some of the finer downtown terra-cotta facades, often obscured by movie marquees and shop signs, but nonetheless there. In various structures formally designated "nondescript," there operated a Designer Mart specializing in odd-lot sales (scarves, pantyhose, tube socks, and the like), a popcorn shop, a cheap steak joint, and the Treasure Chest, a dark and noisy video arcade, one of the best in the city. Block 37 was the sort of place where American Scene painters such as Reginald Marsh would have found their subjects – it was Chicago's version of Fourteenth Street in Lower Manhattan. You had to know it to like it, had to feel comfortable playing Mario or Pole Position elbow-to-elbow with a black kid who had his name carved into his hair, had to have moxie, chutzpah, *cojones*.

You had to be a downtowner to haunt these places. For visitors and tourists Block 37 was best seen at a distance, appreciated not for what was there but for what wasn't. Because it lacked the high-density high-rises that were increasingly filling up the Loop, it was a marvelous hole in the wall of urban density, a sublime vacancy where you could see into the internal organs of the city. And this quality grew rather than shrank as condemnation proceeded and the buildings came down. In the maps and illustrations of planners it was a square hole, usually black; from the street it was an open field, a sky gate. Looking west, it was the frame for the urban wall. Looking east it was an anticipation of the vastness of Lake Michigan.

But its very nature as an inadvertency, a visual surprise, marked it in the annals of planning and urban development as one of the great boondoggles of an era of boondoggles, an insult to the profession, a jeremiad against its hubris. At the end of 1989 one Chicago city planner had cried that "you'd be hard pressed to find a more premium block anywhere in the United States"; a year later it was "slumping" and "forlorn," its demise recorded on Wednesday, December 12, 1990, on the obituary page of the *New York Times*.

It still waits, with its saplings and its plywood walls, its mining-town mobile home "warming huts," and its underused oval ice rink. How shall we model it?

There is a computer program called SimCity that allows you to build, save, and destroy cities. In SimCity the view is nothing like the one you see as a city visitor. It's the picture you get from an airplane window, a grid rationalized by distance, offering the promise of omnipotence to match the omniscience of the skies. It's better than that, actually; it's clearer and more direct, and everything's labeled. It looks, in fact, a lot like the illustrations city planners used to delineate the significance of Block 37 in the press releases of the eighties. Enter the program, and it constructs a topography you can build on: "Now terraforming," the screen tells you. God creates the heavens and the earth. Then you build.

SimCity is a product of programmer Will Wright, who in the mid-1980s hired on to construct what he recalls was "a Japanese shoot-'em-up" aerial combat game. The bombers flew across water to islands and across the islands to specific targets. Wright had to design each island and its various elements: roads, trains, houses, factories, banks. So he built a little sub-program – a "utility," he called it – to make matters easier. Then he began to fiddle with the utility.

Like many programmers of personal computers, Wright had an unorthodox past. He had gone to college in Louisiana and New York and had been exposed early on to the disciplines of architecture and urban planning. While he was in the midst of his city program, someone reminded him of research that MIT's Jay Forrester had done in the late 1960s, work that brought to city planning the discipline of system dynamics and its use of big computers to model and predict the ways complex systems work. Using many of the computer models that underlay Forrester's "urban dynamics," Wright came up with a program that created a terrain deemed logical for city development (there was always a river, for example, coursing through the center of the topography). Equipped with a sum of money, the player then began to organize a city, building power plants, providing transportation (roads and rail transit) and a power grid, and

the sharpness and depth of a good color photograph. Both picture window and computer monitor offer the viewer an engrossing image, mutable, rarely at rest. Where they differ is in their underlying ethos. Computer programs work by logic; they are governed by rules. One programmer described SimCity rather contemptuously as "a spreadsheet with a picture on top of it," and he was right. It mirrors the distinction Mark Miller made between the "hard facts" behind the scene and the soft facts of the public picture manufactured after the deal is done.

SimCity may look like a good model for Block 37. On the new incarnation you can, in fact, make a city that replicates the Loop down to the distinctions between government buildings and commercial offices and shopping areas. But when you run it, Block 37 doesn't lie vacant for years. A high-rise complex pops up within months. SimCity, it appears, replicates the thinking of the city planners and real estate developers who put together a deal and wait for it to work. But it doesn't replicate history very well. For one thing, it doesn't believe in recessions that freeze capital. It doesn't have irate preservationists, or the law courts they use to obstruct progress. It doesn't have politics deflating or inflating the value of the property, encouraging and discouraging development with a disorderly enthusiasm that resembles chaos theory more closely than computer logic. It doesn't have housing inspectors who take gratuities or mayors beholden to their backers.

And yet in the face of SimCity's obvious failure to conform to the reality outside the picture window, downtown workers with good office addresses bought out the game and, turning their backs on their windows, played it and played it and played it. It wasn't a model for urban reality. Instead, it was a soothing mantra of orderly escape from the chaos of the street. Its high vertical view of the city – distant, cool, and engrossing – corresponded to the laws underlying its relentlessly logical narratives. As above, so below: unlike the city outside.

Out there, it seems, another model might be more appropriate: Babel. At least it must have come to look that way to the planners and dreamers of the 1980s who, again and again, found their plans and dreams thwarted by unruly events, obscure laws, the enthusiasms of

mayors, the voices of the street. How better to explain the momentum and inertia of the city behind the simulation – the city that denies the simulation – than as a divine decree to thwart the utopian ambitions of humankind? As the Bible tells it, it's a reassuring model:

Once upon a time all the world spoke a single language and used the same words. As men journeyed in the east, they came upon a plain in the land of Shinar and settled there. They said to one another, "Come, let us make bricks and bake them hard"; they used bricks for stone and bitumen for mortar. "Come," they said, "let us build ourselves a city and a tower with its top in the heavens, and make a name for ourselves; or we shall be dispersed all over the earth." Then the Lord came down to see the city and tower which mortal men had built, and He said, "Here they are, one people with a single language, and now they have started to do this; henceforward nothing they have a mind to do will be beyond their reach. Come, let us go down there and confuse their speech, so that they will not understand what they say to one another." So the Lord dispersed them from there all over the earth, and they left off building the city. That is why it is called Babel [that is, Babylon] because the Lord there made a babble of the language of all the world; from that place the Lord scattered men all over the face of the earth. (Gen. 11:1–9)

What a temptation, to declare Babel as the fate of cities! For the legend elevates the profession of city building to the level of messianic purpose, its roots in a time of world hope and unity, its purpose to draw people together in harmony, its destiny to rival God, its tragedy to be struck down by a wrathful, irrational divinity, so that the failure of its utopia resonates through human history forever. Who would not relish being cloaked in such a myth?

The planners' enemy is the street, with its babble of voices, its disconcerting energy and disobedience, its clash of influences and war of images: Kung fu movies. Caramel-corn stands attended by beautiful black women, improbably young, dressed in nurses' uniforms. A discount stereo emporium with its Pakistani shopkeeper lounging in the doorway and all seventy-three of its stereos, boom boxes, tuners, radios, and Walkmen blaring WLUP, Block 37's rock station

supreme. Tube socks on a folding table illegally crowding the entrance to the Designer Mart.

From high regions above the street, it's hard to see these pictures, hard to hear their accompanying rhythms. In SimCity the urban matrix evolves silently, so as not to disturb the secretary in the outer office or distract the mind from the work that continues in the background: the number-crunching spreadsheet, the game plan turning from ephemera to hard copy on the laser printer. Up there the window frames a view stripped bare of the street's disorder.

But not everyone up there fears the street. Perhaps there's another picture of Block 37, as a welcome interruption. As you leave the Chicago Theater at night, or return to your car after sunset in the winter, Block 37 looms darkly, an absent presence, counterpoint to both the established and the new. Walking past it in the morning, from the parking lot or the el stop, you feel a quixotic tug as you realize that the views it gives you won't be there much longer, nor will the silence, the trees, or even the skaters you might see from the window of your office before you turn away to work — skaters whose looping, graceful patterns counter the brisk rectangles of the rest of the view.

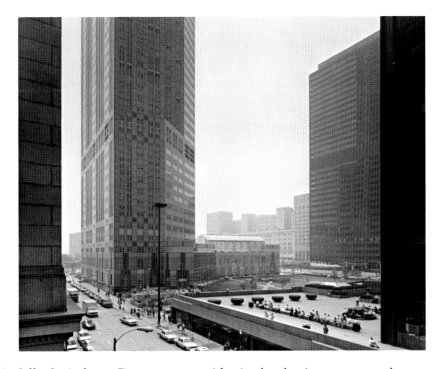

The American city is full of windows. Downtown, outside, in the daytime, you may be seduced by the street and miss their power. As you come up from the Grant Park underground garage in Chicago, a man with no legs, wearing an indecipherable sign around his neck, solicits money. His coffee can is stuffed with bills. On the south side of Randolph Street a store blares new age music from a pair of huge speakers. Another half block, and you're under the el. Sound, light, human occurrence: everything is deflected, repeated, refracted – even you yourself are unsettlingly disintegrated and reintegrated as you walk. Two men brush past, running on their toes, flat out; one is chasing the other. You have an appointment. Who notices windows?

But the view down here is exactly backward for understanding the significance of windows. Here you are, on the outside looking in, and you aren't seeing anything. Inside people are looking out (maybe from a lunchroom in the IBM Building, where nothing is ever awry and the action outside is just a backdrop to the drama of the deal), and they can see *you*.

FRANKLIN STREET AT ADAMS STREET, VIEW SOUTHWEST, 1990

Outside, you're the object. Inside, you own the view.

If you work in the city and your work matters to others, how much it matters is expressed in the space that is yours, and the view you own. One makes you the object of desire; the other, the desirer.

To begin with, there is the vertical hierarchy. The higher up you are, the higher up you are. The axiom holds categorically; it holds firm by firm; it holds by individual.

Retail is at the bottom: it has to be – it's the realm of the street, "down on the street." This is where contingency, risk, the gothic romance of the city operate. Here today, gone tomorrow.

Downtown, retail is the zone of incipient failure. Carroll's is down. Macy's is down. Carson Pirie Scott will have to go down before it gives up its Louis Sullivan flagship store on State Street, with its organoform decoration and the animated Christmas window displays that draw people to the city all during the season.

Above the retail stores are the marginal institutions – the schools of beauty, the downtown branches of colleges and universities, the secretarial schools, H & R Block. Bad lawyers have their names in gilt on the windows of the older buildings. The second and third floors (maybe the fourth) are the haunts of private eyes, of Spade & Archer, Philip Marlowe, V. I. Warshawski.

In the modernist buildings, architectural practice masks economic reality: the bottom floors often aren't worth renting out. So they become honorific spaces, with their angled glass directories listing every rent-paying tenant, their elevated desk for the doorman who is also security: and then the banks of elevators, each with its own destination floating above eye level: 2–23, 24–45, 46–61. Three-story ceilings, block-wide floors: so much waste that even the casual visitor knows the space is monumental, if not religious. Vast public spaces – aren't they universal icons showing what's truly privileged in a culture?

Above these streetwise layers begin the levels that accommodate what's important. Big businesses, huge law firms, advertising agencies, magazines, all rent blocks of floors. A good-sized law firm in Chicago might occupy thirteen floors of a major skyscraper. Banks, of course, own their buildings. They locate where they want to be – the higher up the better. Rumor has it that Robert Abboud, then chairman of First National Bank, ordered the architects for the

rest of Chicago's First National Plaza to keep the other buildings lower than the one where he had settled (on the top floor). He didn't want his view obstructed.

The rumor may not be true, but the axiom behind it remains unimpeachable. Senior partners occupy the top floors; associates are below them. And on each floor the view defines the office, the office measures prestige. Corner offices are most desirable; at the end of the hall, often at the intersection of halls, they afford access from multiple directions. They offer both privacy and surveillance (if you walk that far down the hall, you're expecting to be admitted to the corner office).

But time and the engines of enterprise turn ideal plans into patchwork. When boom times spur untrammeled growth, where the new partners fit in may depend on available space. Partners don't necessarily move to more desirable offices in an orderly fashion. They may decline to move, because they like the space they occupy or enjoy the privilege of a certain anonymity. Casual visitors don't understand just how important they are; the insiders know.

But this is not common. Most people rise to their new offices, or move to those elite corridor suburbs, with gusto. Their new assignment signals their change in status – to clients, to colleagues, to the associates and underlings. Inside the office there's the matter of square footage – higher and bigger, and higher *is* bigger. But the true symbol isn't the size of the corner office: it's that it commands two views, both dominated by the vectors of streets or avenues that (in a good flat city, built on the grid) recede to infinity.

But that phrase – command the view – is deceptive. The office doesn't command the view, its occupant does. And herein is summed up the integral relation between the aesthetics of cities and their ownership. Architects pretend to possession: they build the windows the owners look out from. They, the urban planners and politicians, and to a lesser degree the organizers of the street all claim to define the city's fabric. From up here they are set designers, bit players, walk-ons, creating the dramatic production that is the city view.

On Michigan Avenue in Chicago, on the west side of the street close to the river, is the building that houses the Institute for Psychoanalysis. When it was built in 1926, it was a solidly re-

spectable masonry structure of some twenty-three stories, designed to house the Nalco Chemical Corporation. Now its facade is covered by a metal bas-relief added when the building was renovated in 1967, a work that appears, at least, to represent the workings of the unconscious as conceived by that institution when it was still orthodox Freudian, before the apostate psychoanalyst Heinz Kohut shook the foundations of the institute and the profession.

The building is old. Its windows aren't the floor-to-ceiling type that dominates the modernist buildings where big law or big business sets up. They are casement windows, and some have chicken wire embedded in the glass. Nonetheless, you can see out. The windows in front look across Michigan Avenue to the entrance of Illinois Center — they have a full frontal view of the welter of forms, light-struck, mutating, punctuated by the business of the street. In some of the offices, if your chair or couch faces that way, you can see around the south end of the plaza to the lake.

The rear offices look west. They peer over a series of low retail structures (one houses Mort's Delicatessen), across or around pieces of other buildings (including the Chicago Theater) at State Street, and across it to a nearly vacant city block, Block 37.

Seen from this angle, Block 37 is far different than when we saw it last. We can't detect the absence of the McCarthy Building. Instead we see the presence of space. It's a vacancy to be relished, an opening into the core of the perfect city.

But it's different than it looked from the street, seen by tourists who care not at all how long the block has been vacant or how much money it's worth. Now we are up where the new cliff dwellers live out most of their lives. The view of Block 37 from the many windows that rise around it is a welcome relief from a spreadsheet program, but it has a certain piquancy, especially if you happen to know that your annuity program, your insurance company, your pension fund put money into FJV Ventures. Like the keychain with the image that's Christ if you hold it one way and the Virgin Mary if you hold it another, Block 37 at this angle is sometimes space to be savored and sometimes money to be mourned.

But we are at this moment looking out the windows of the Institute for Psychoanalysis. This

is the hour when we're free of the cash nexus (till we get the bill, that is), free to free-associate.

We can see this space in Bob Thall's 1991 view (p. 15) made from the parking lot that abuts the institute's building, facing State Street. How we enjoy this absence! In the distance are two works of high modernist sculpture. One is the Picasso, looking from this vantage point like a piece of scrap metal left here temporarily. Across the street is the other – the four-story Commonwealth Edison Substation. From this angle it's hard to discern its enduring architectural merit, but it's a wonderful surreal mass set ironically in a tipped arc of fallow ground. As if to emphasize the point, a cowboy tries to leap off the billboard on the Shoppers Corner Building right into that space, making it for the moment a rodeo arena.

(Even a few months after the picture was made, none of this holds true, at least for the people whose windows face this view. The billboard cowboy has left; the vacant lot is now a public skating rink. Only in this photograph are we treated to a rodeo with an audience of city buildings.)

Images like this are at one extreme of the range of views you can own if you work downtown and your work is deemed important. They are views full of the accretions of time, made possible by changing fashions in building height (and changing construction technology); by the ways capital comes and goes in the urban economy, emboldening or bankrupting developers; by the laws of taste, dictating that today's good design will not likely be deemed good tomorrow. The result is an upper-floor version of the tourist's urban picturesque, full of surprises and delights, irregularity and caprice, clashes and harmonies. Consider the array of buildings, with their varying heights and even more extreme variations of "style." Consider the back of the billboard between us and Block 37. It appears to have a colonnade running across the top (actually it's just one of the accidents of vernacular billboard construction); it includes a shack accessible only by ladder, its door disguised in the wall. Consider the spaces themselves, broken and irregular, the grid of the street plan rendered visible and invisible, then visible again, until it seems hardly possible that from the street the world is logical.

That's just today. Over a decade (or in some cases months) everything can change – a new

building can rise from a hole in the wall of facades; another gap may appear, admitting streaks of light and sharpening the relief of building against building. Anything can happen.

At street level, transformation comes as a clash of urban values, a clash between compatible economies – one an economy of money, the other an economy of symbols, of values, of nostalgia and preservation. Up here it's a matter of aesthetics. Owning the view, one is spectator to a Brobdingagian experiment in sculpture. But it isn't, as the architects assume, a sculpture park composed of monuments, each demanding obeisance and study, forming a set of lessons in the hierarchy of architectural values. It's all a single work of conceptual art, an experiment in the applied laws of momentum and interia, invention and entropy. People are speculating on the outcome (and developers are gambling on it). Up here the odds are on transformation, at least for a while.

But this is a position best held by those in older buildings whose middle-level views (the twelfth floor, say) look across the welter of buildings of various ages, from mid-nineteenth century to postmodern, where land values are high and promise to soon go higher. In the newer buildings – the skyscrapers built in the past two decades and fashionable with the big corporations and partnerships – a different scenario unfolds.

It has two stages. The first is progress, tinged by regret. Progress means filling in the holes around you with other buildings until your view is no longer surprising at all but is simply a faulty mirror, reflecting the same mirrored glass that you look through.

The second stage is accommodation. Once you've lost your view, if you are imaginative enough you will discover other views, equally complex and engrossing, but harder edged, and more voyeuristic. No longer will you gaze across three or five or seven blocks at the pride of three or four distinct schools of architecture and many more unmemorialized representatives of development and growth. You will now look across the setback-mandated free space above your building's plaza and see the stripped modern facades of other high-rise office buildings. And in them will be people more or less like you.

Mirror glass has turned out to be a tenaciously popular material for office buildings. And

PLATES

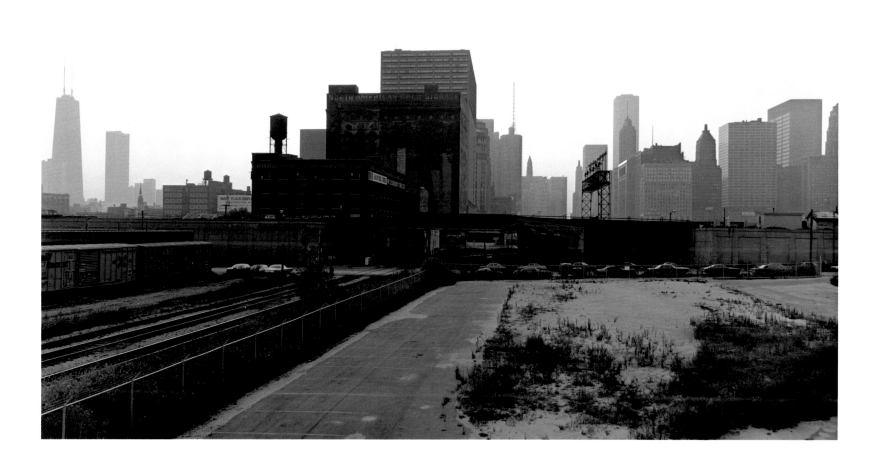

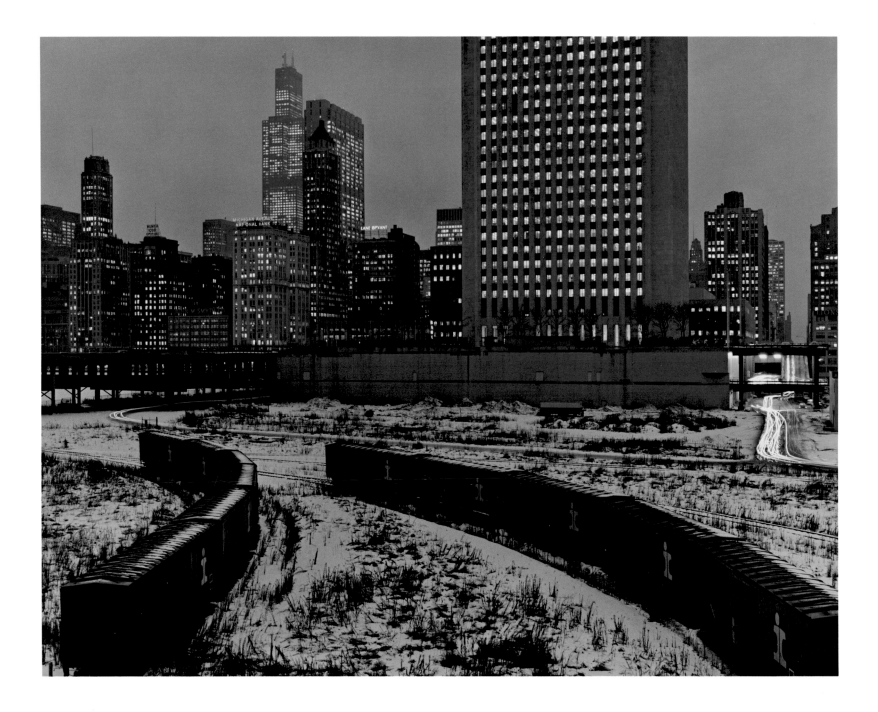

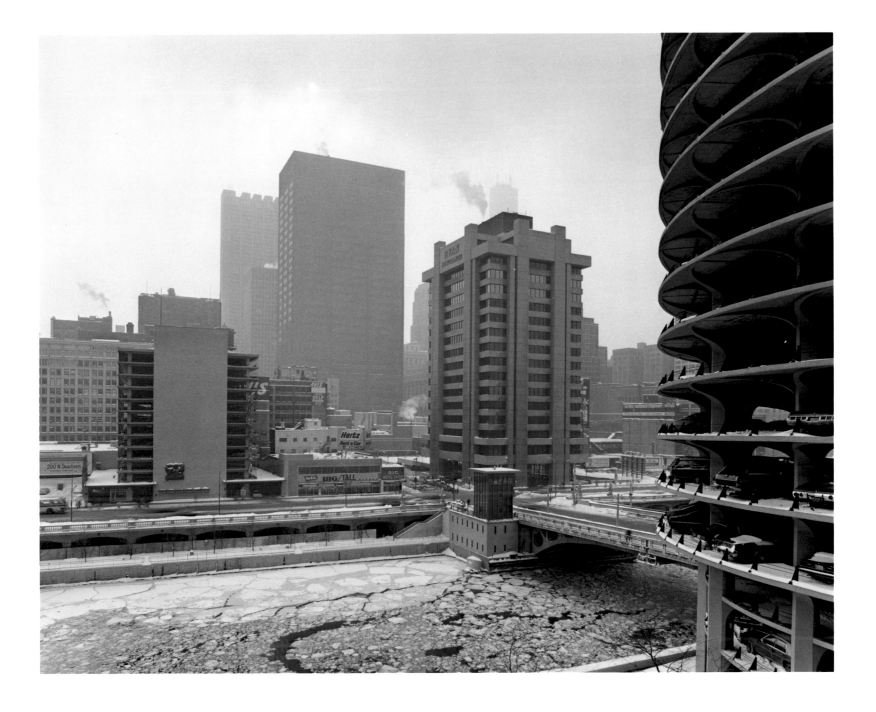

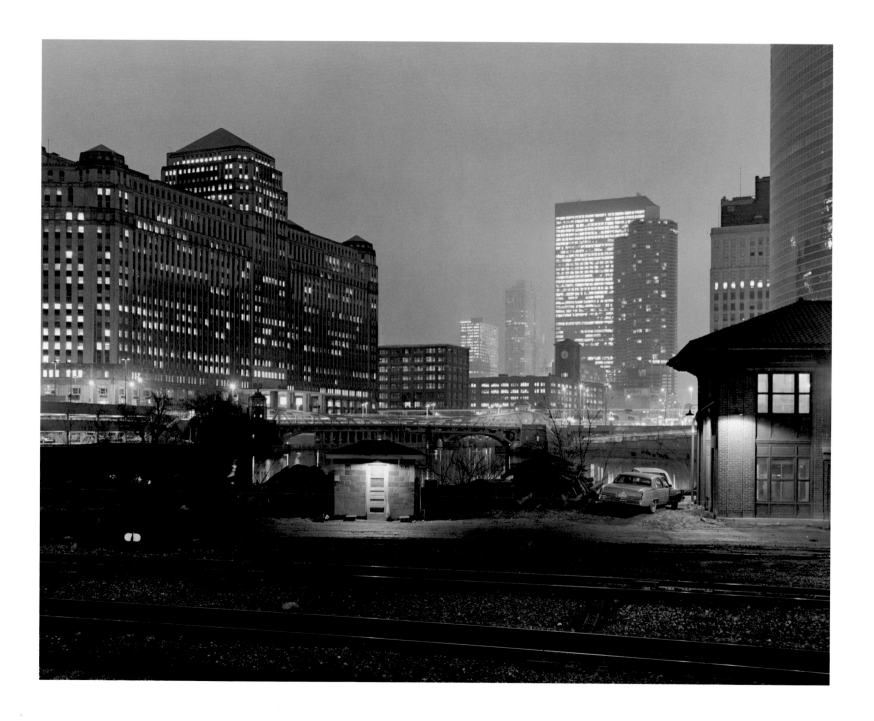

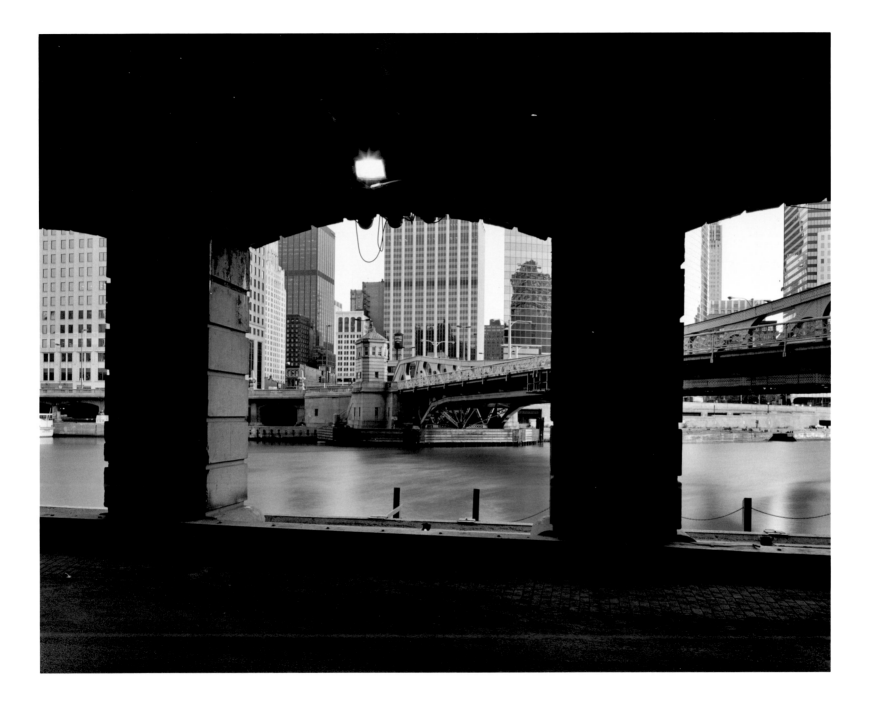

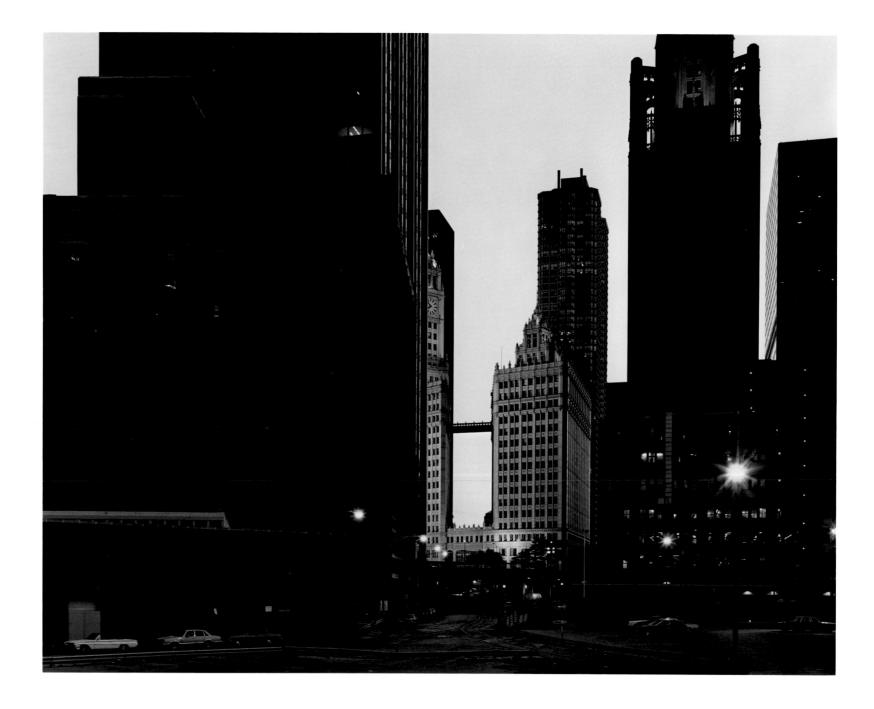

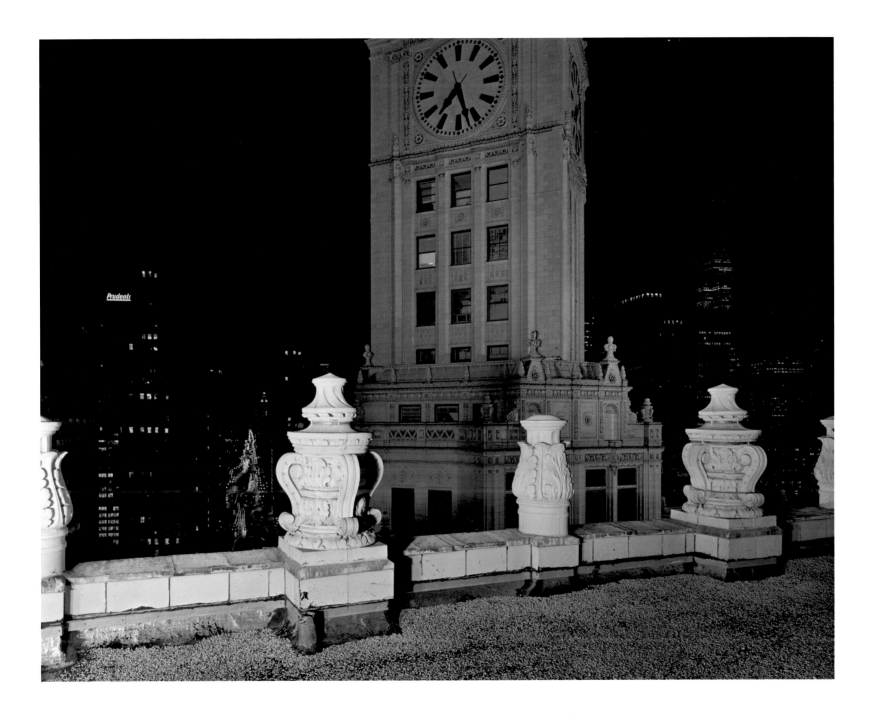

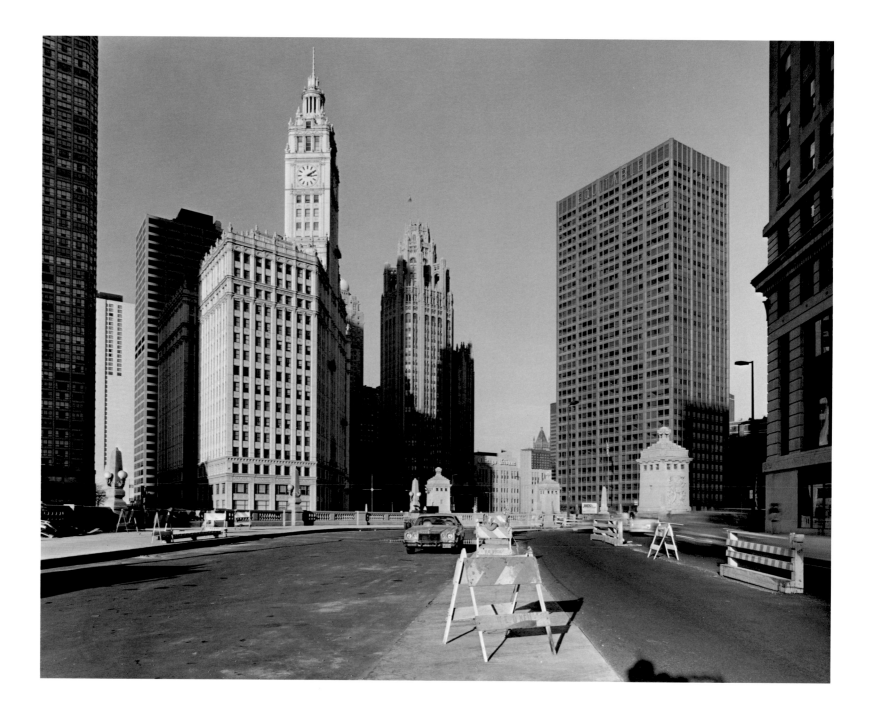

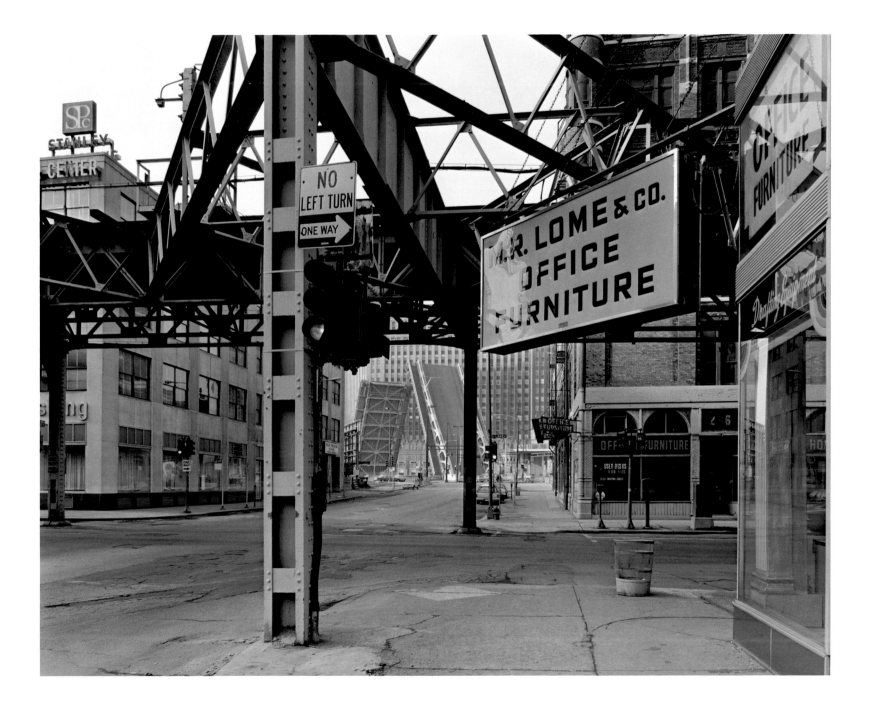

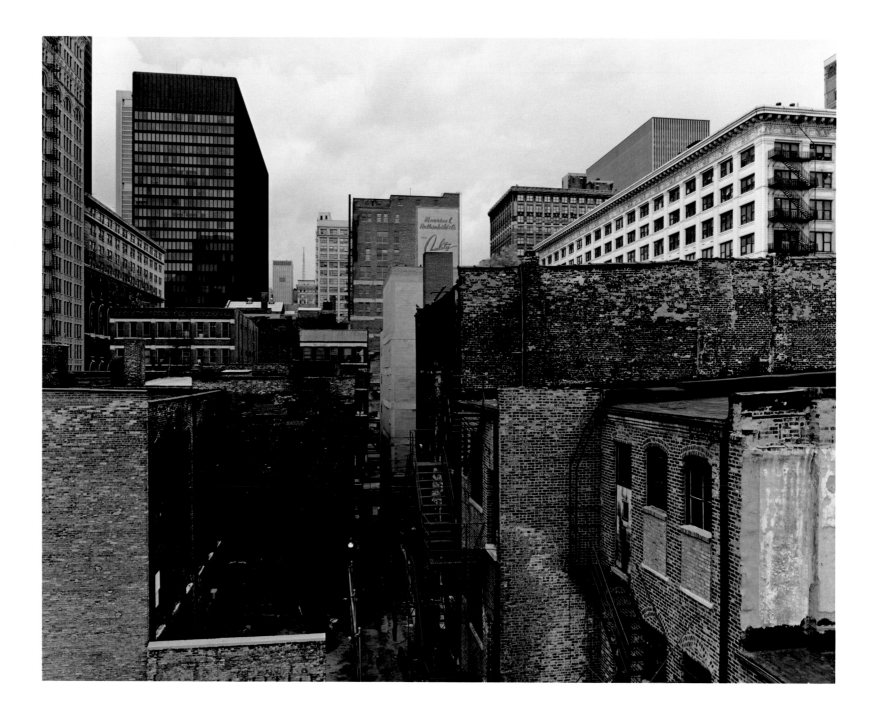

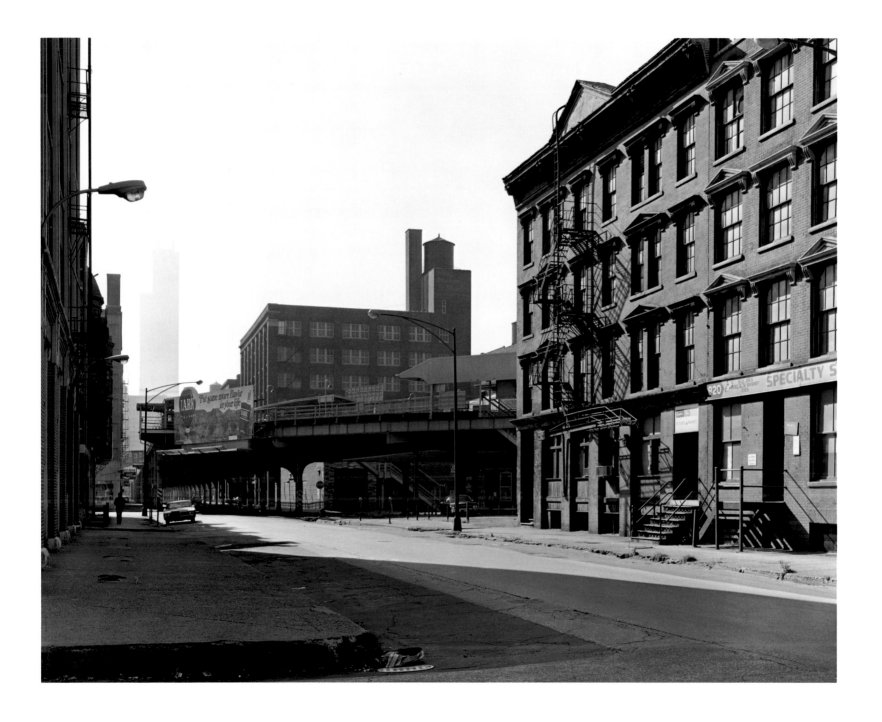

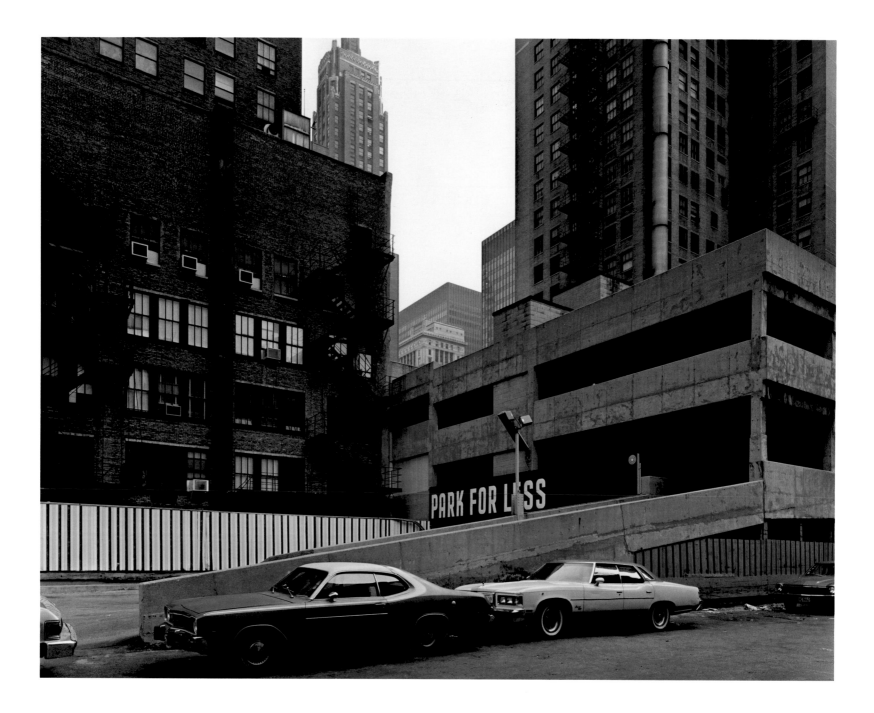

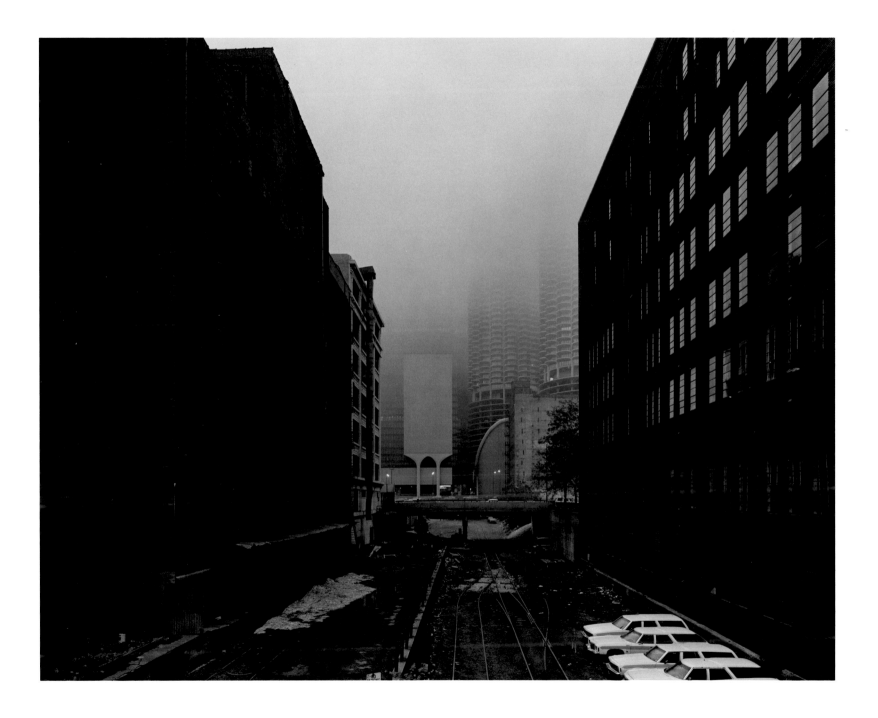

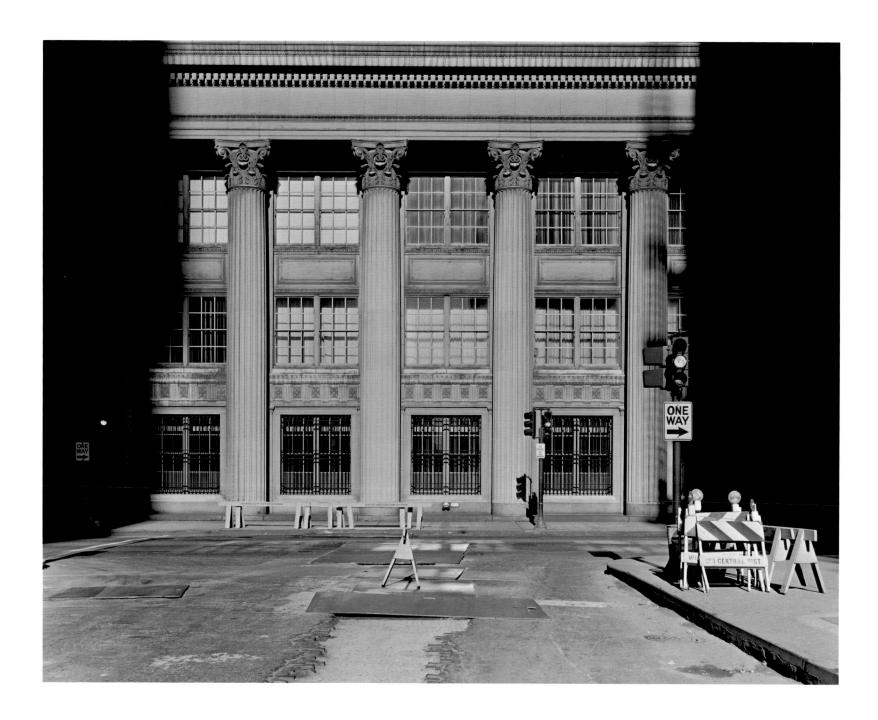

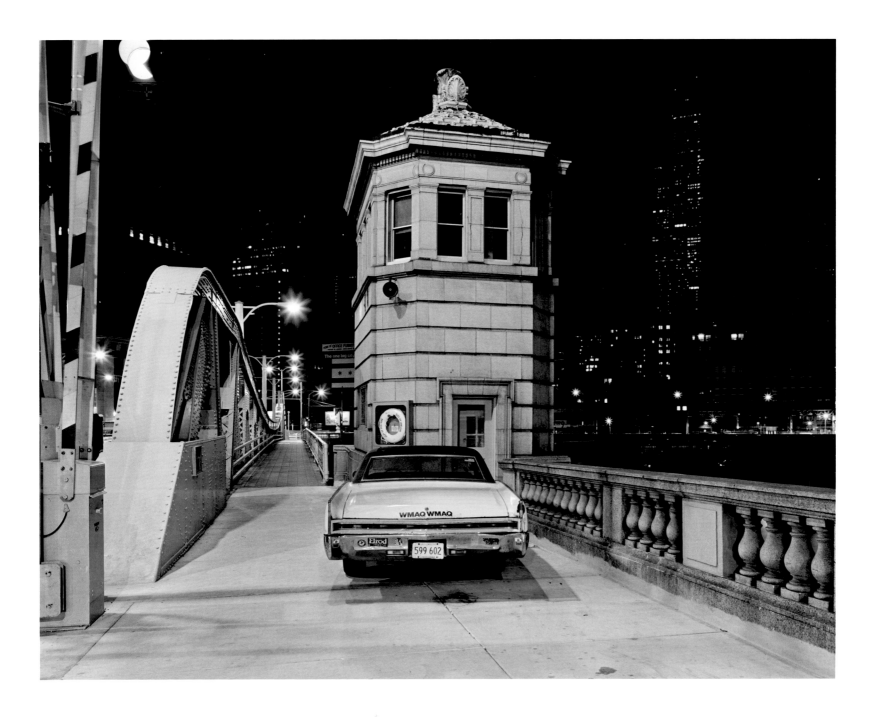

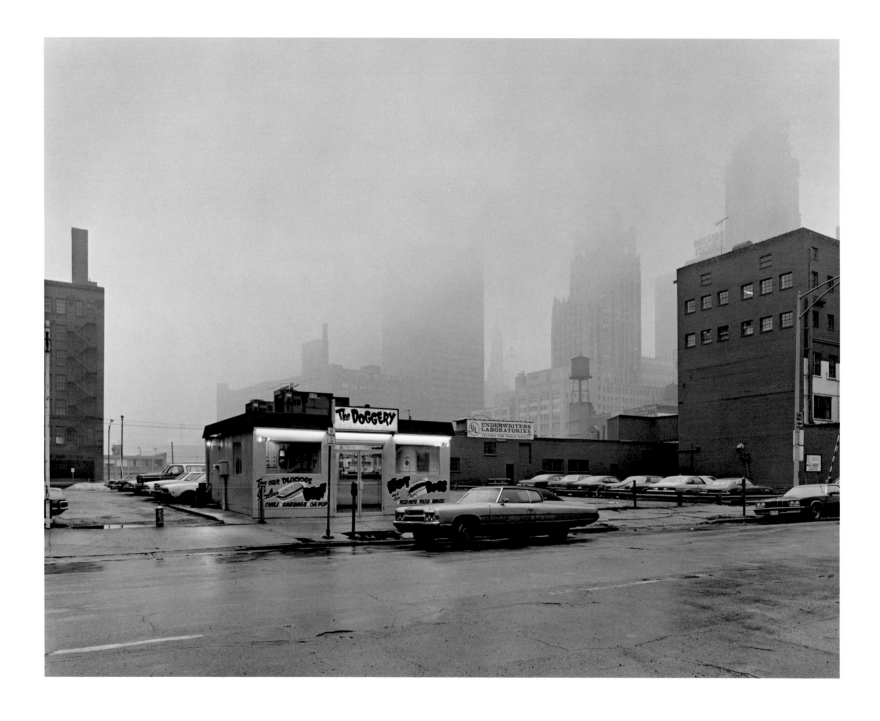

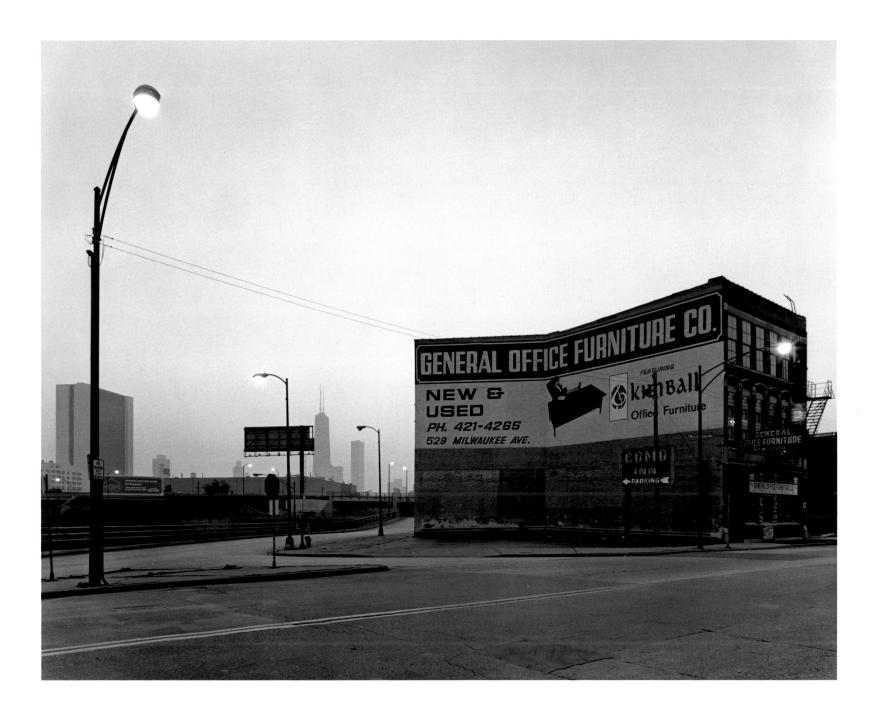

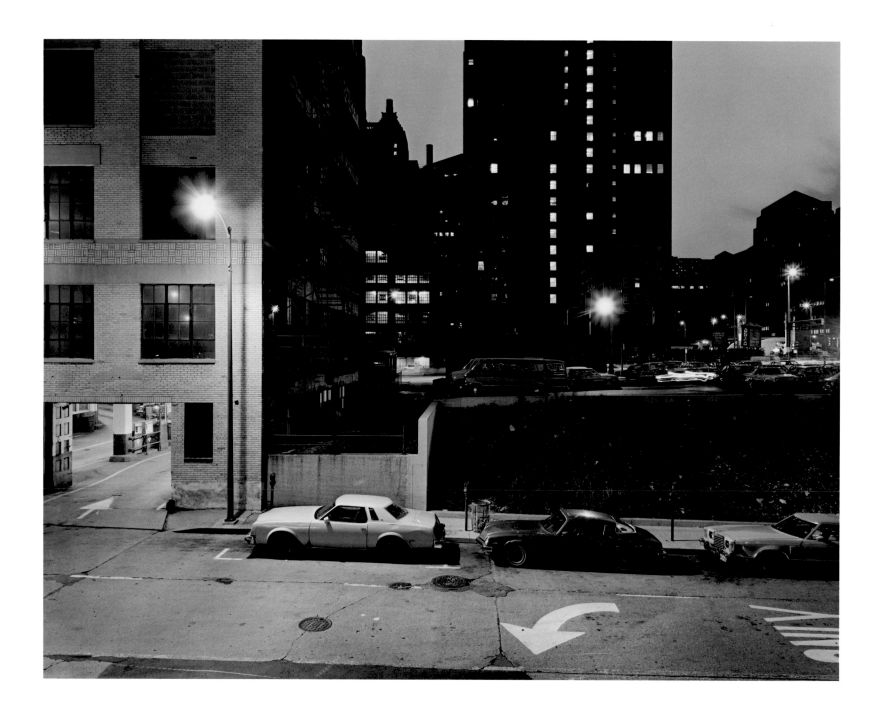

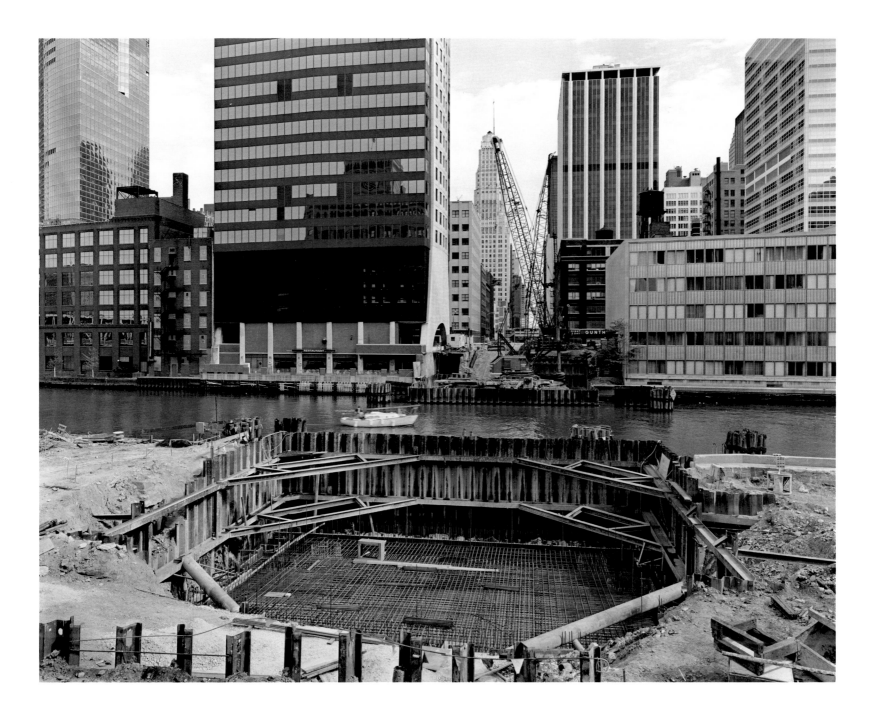

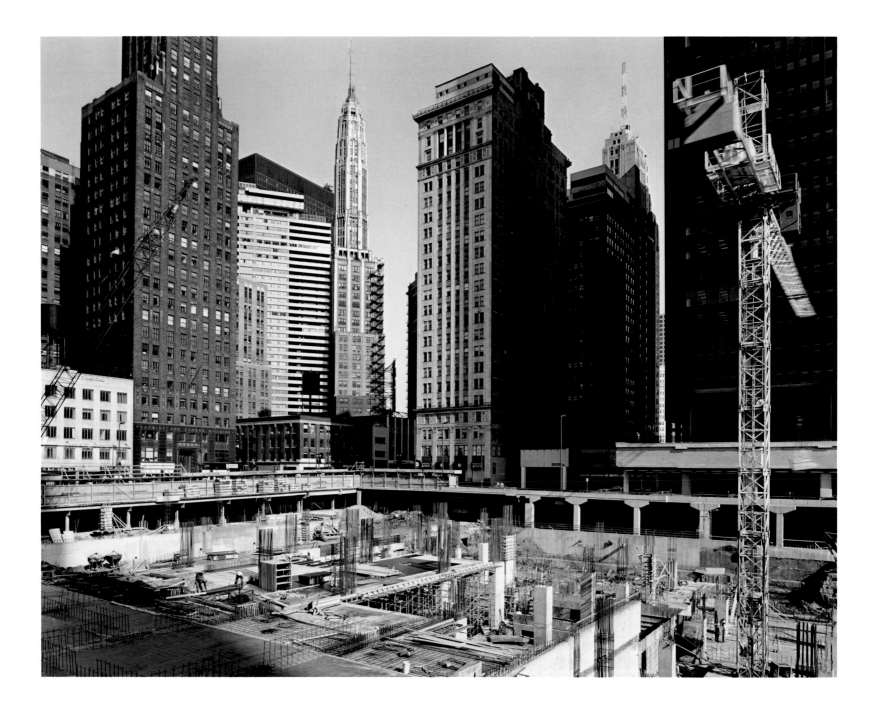

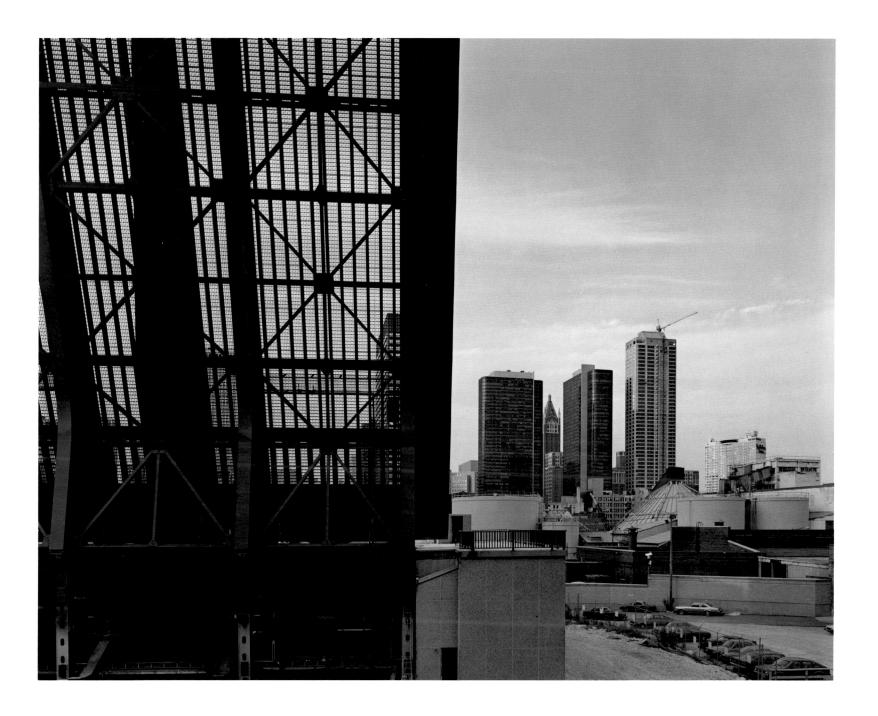

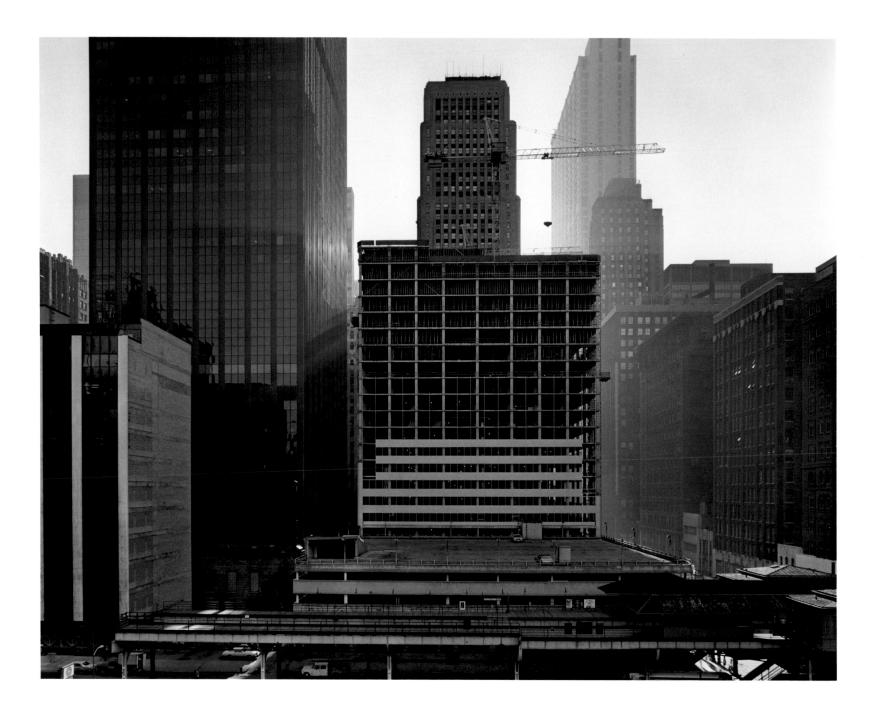

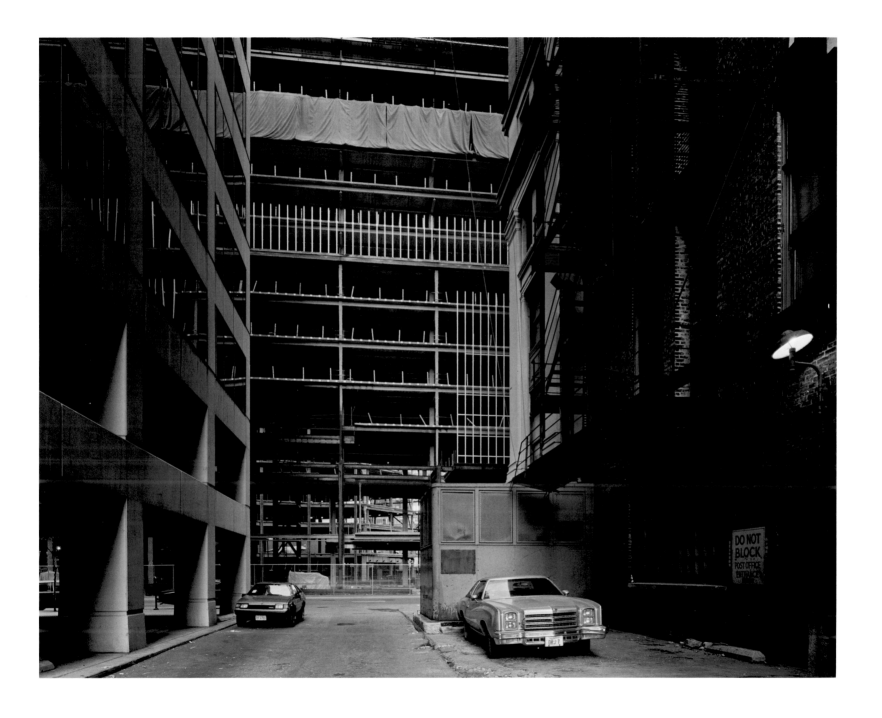

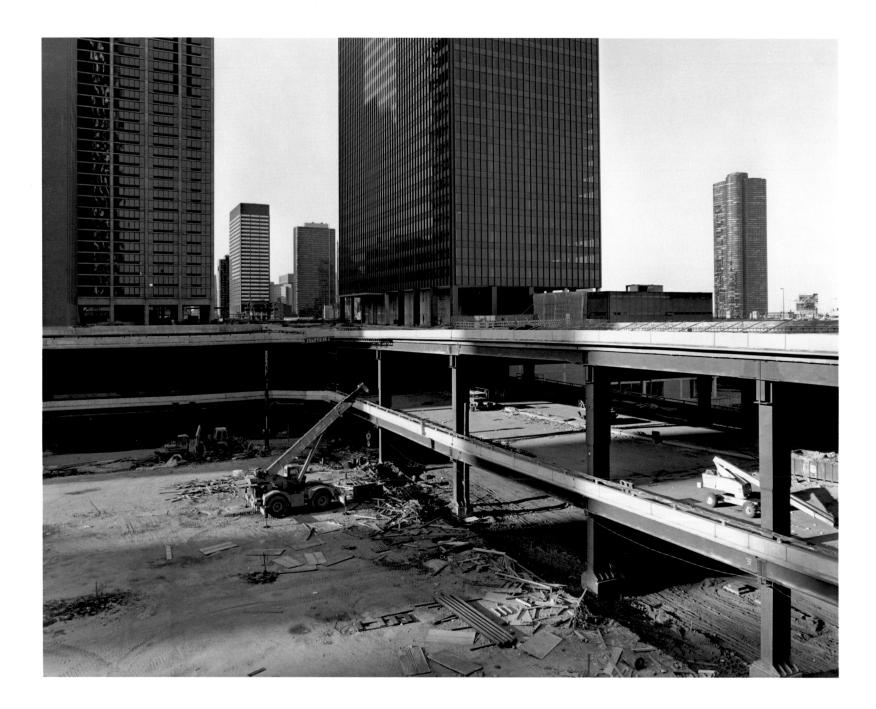

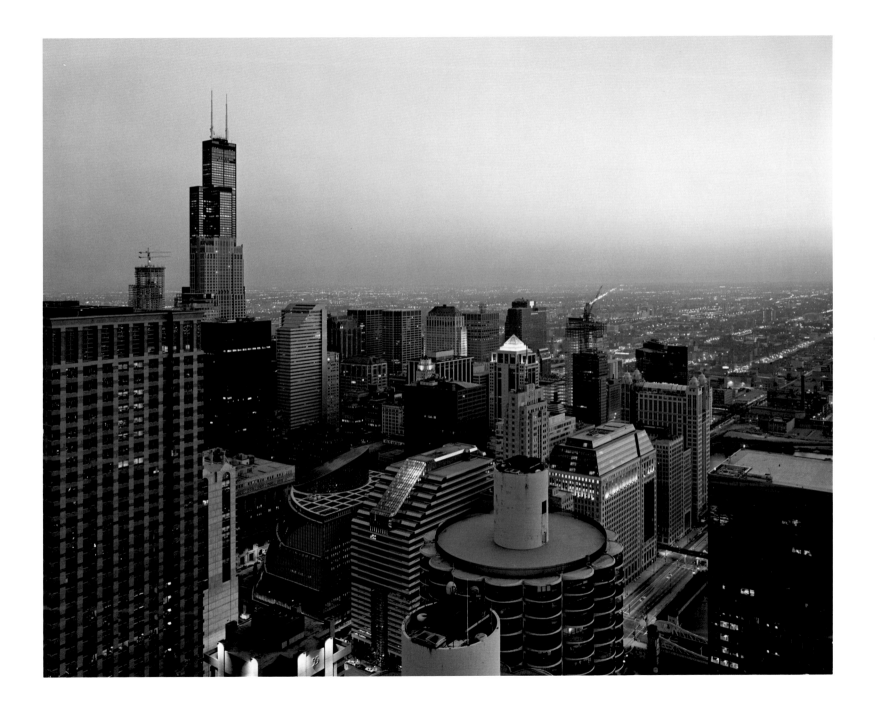

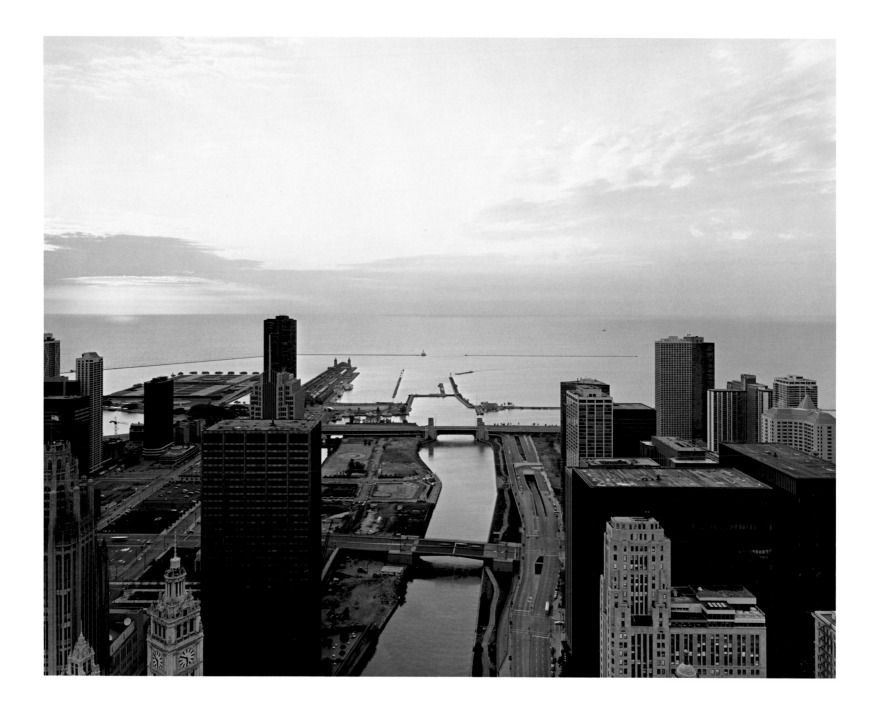

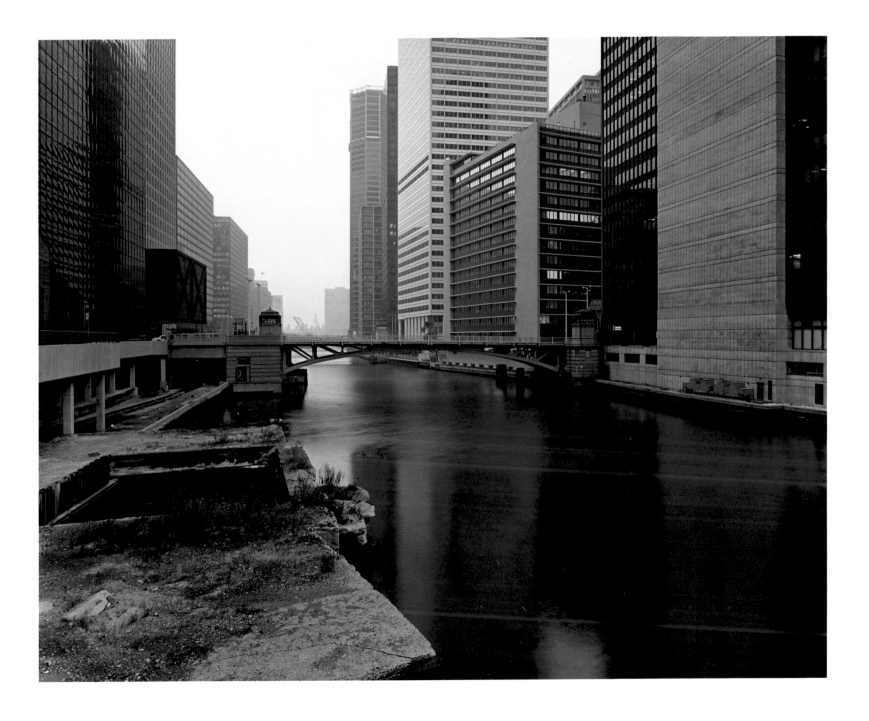

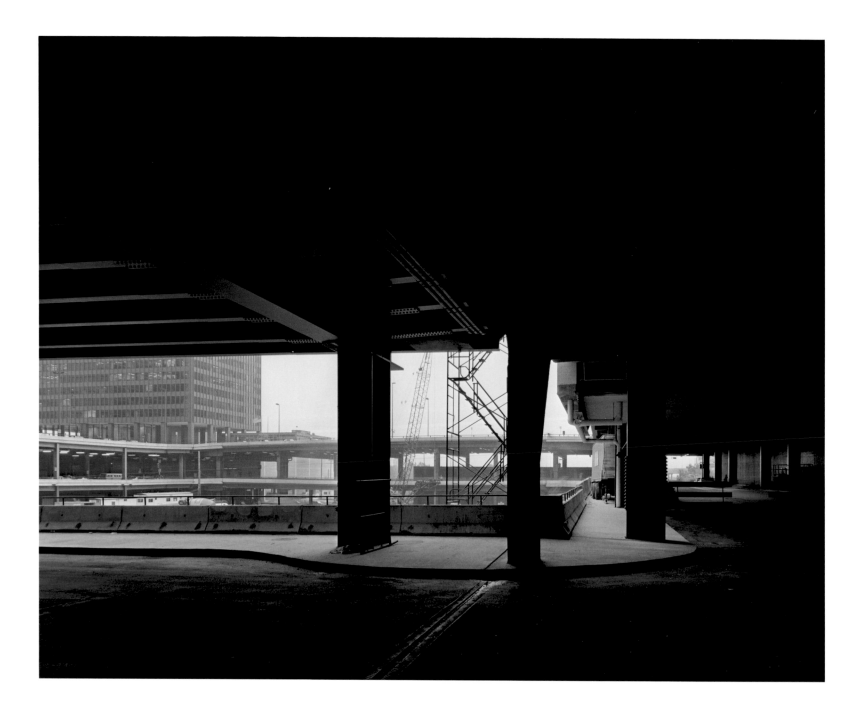

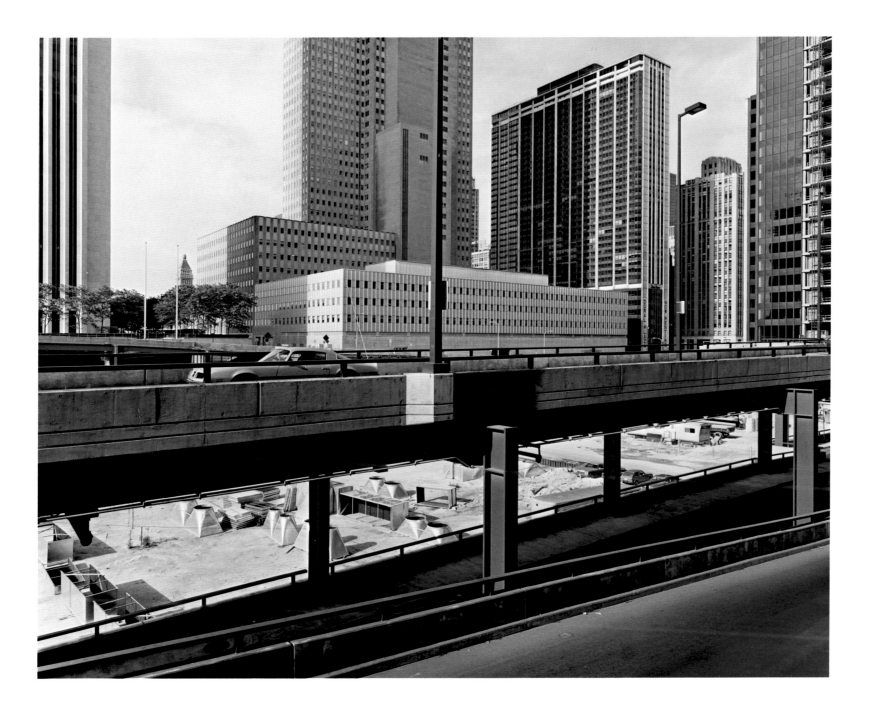

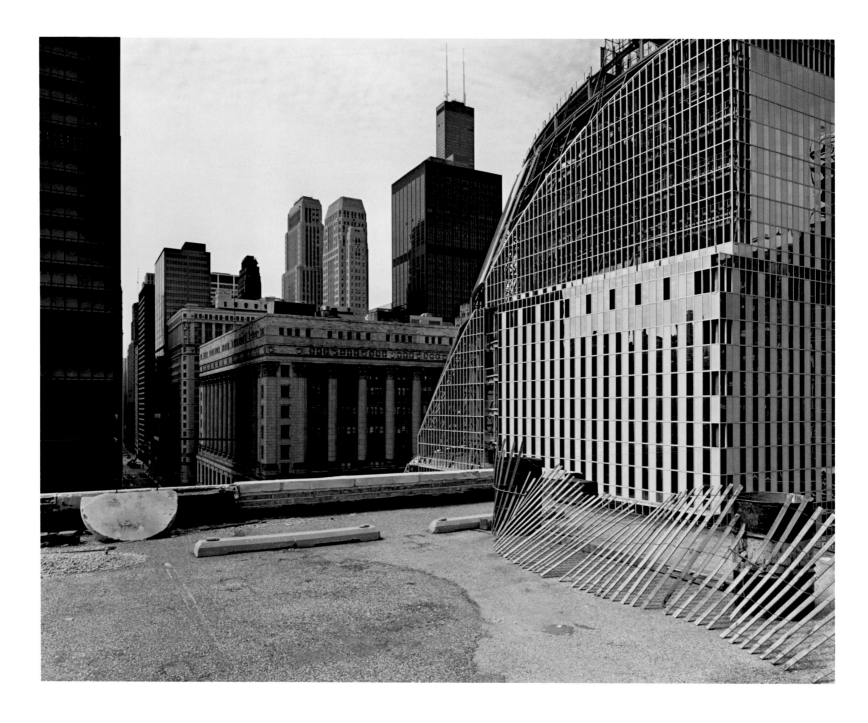

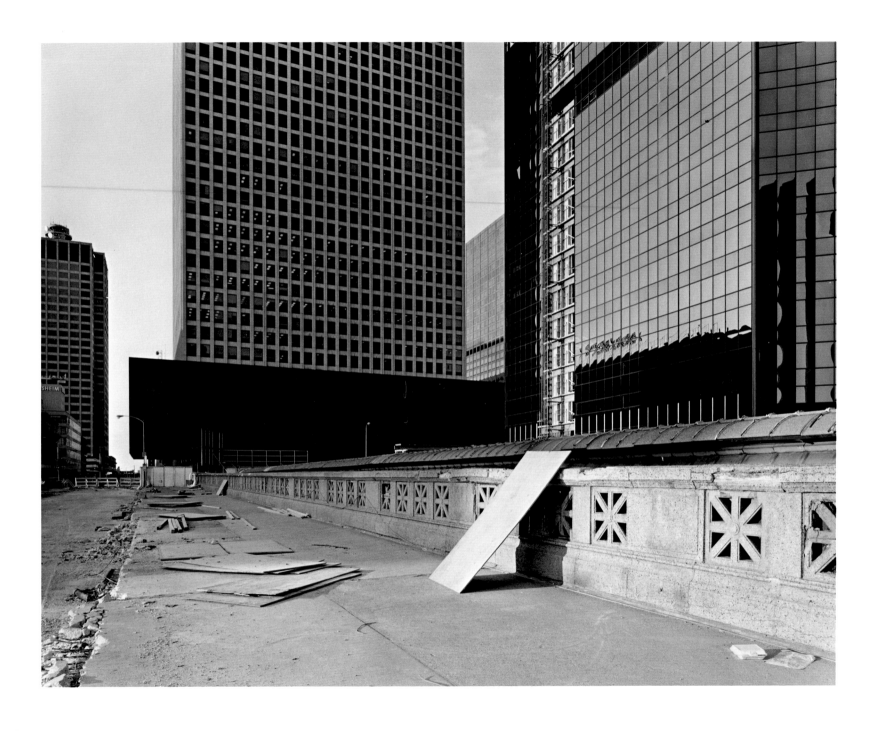

8 9

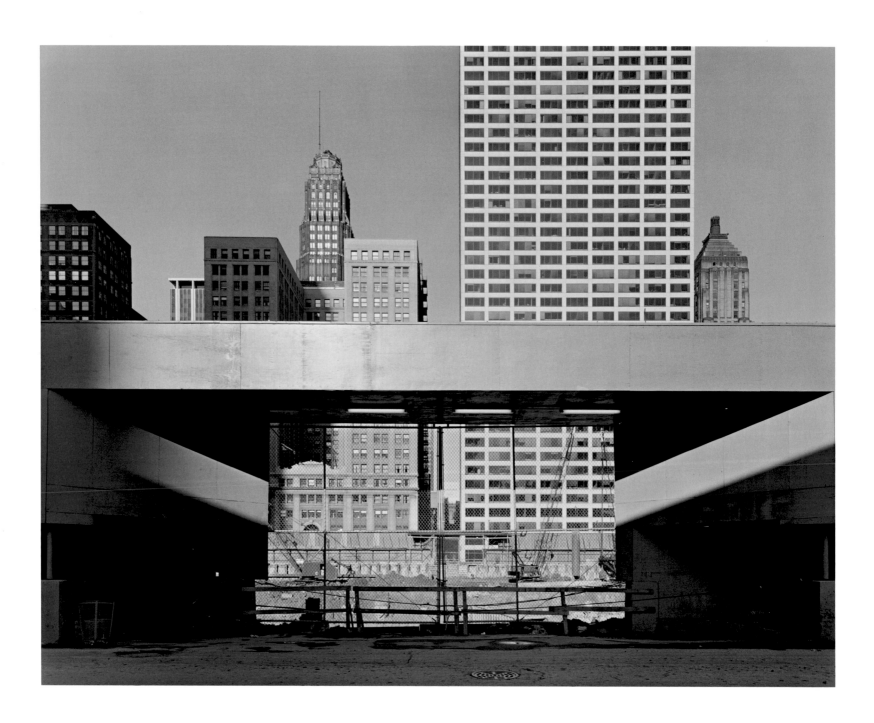

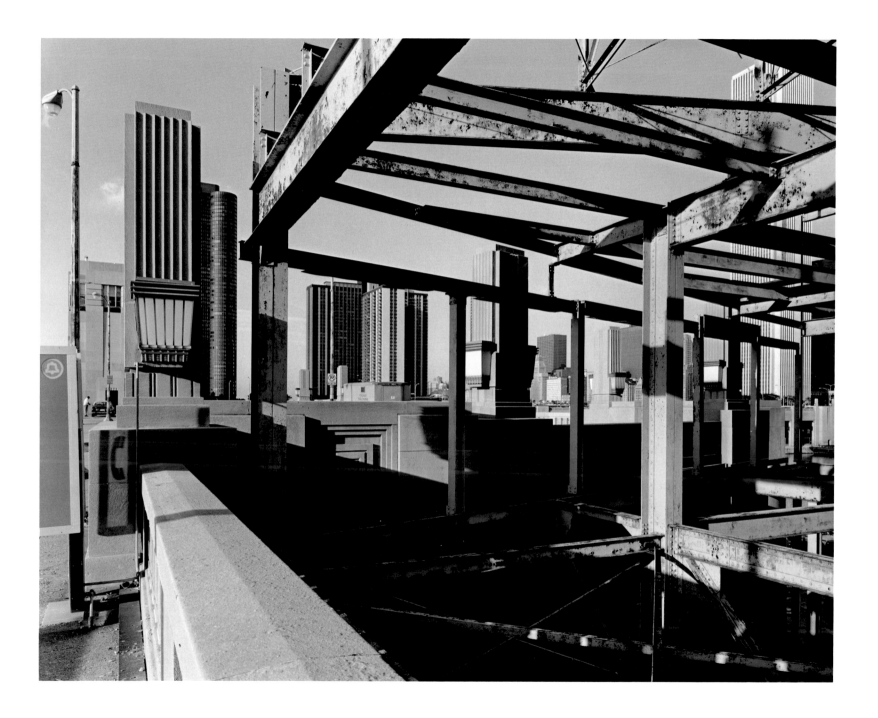

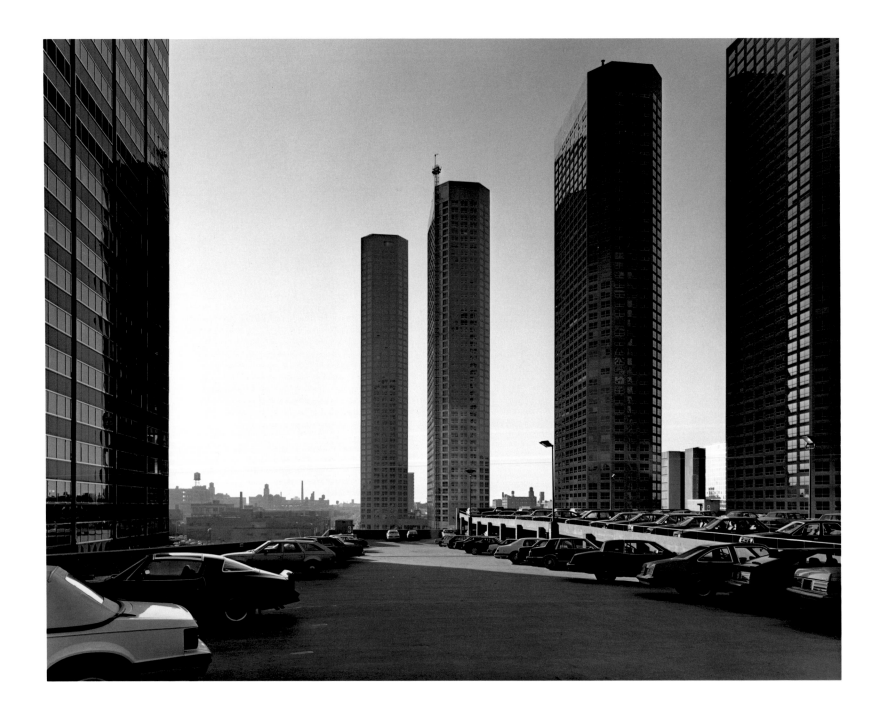

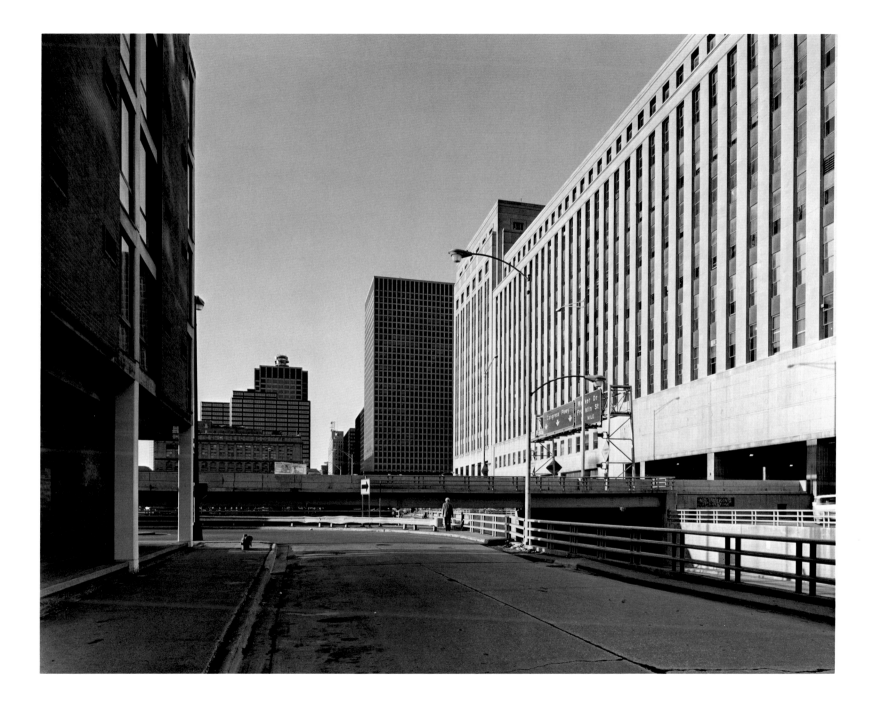

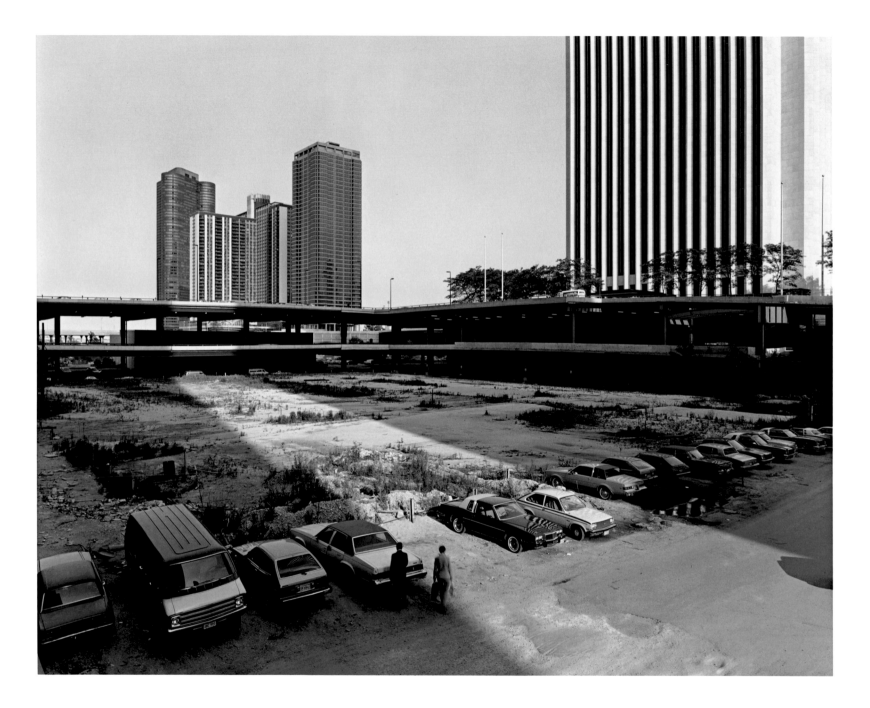

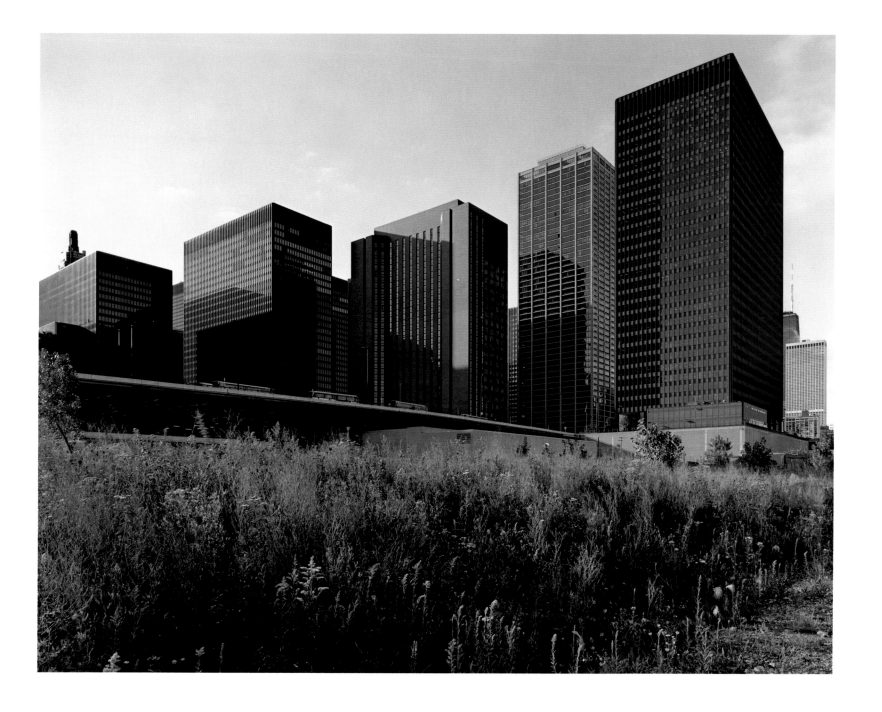

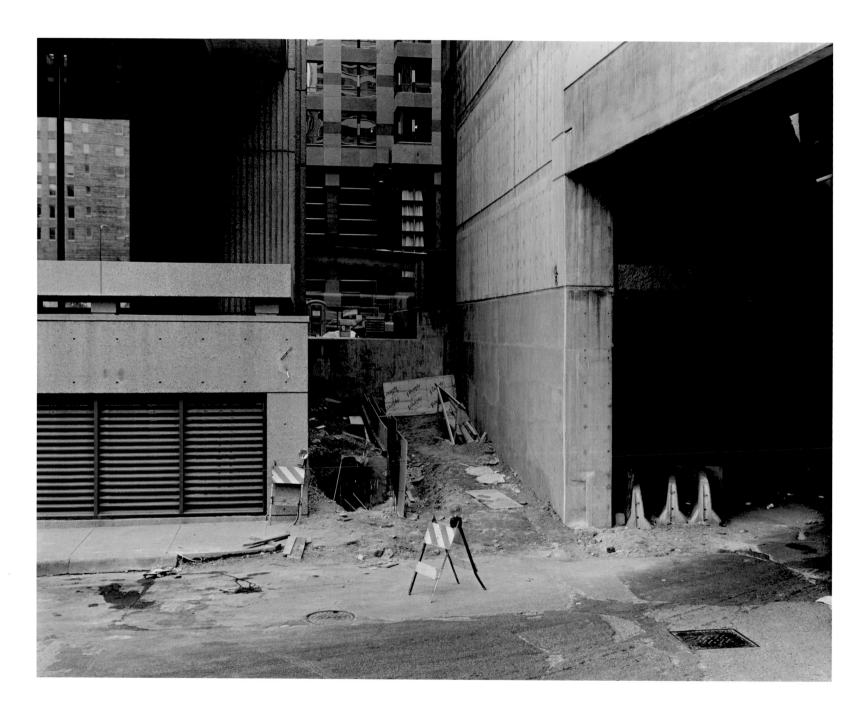

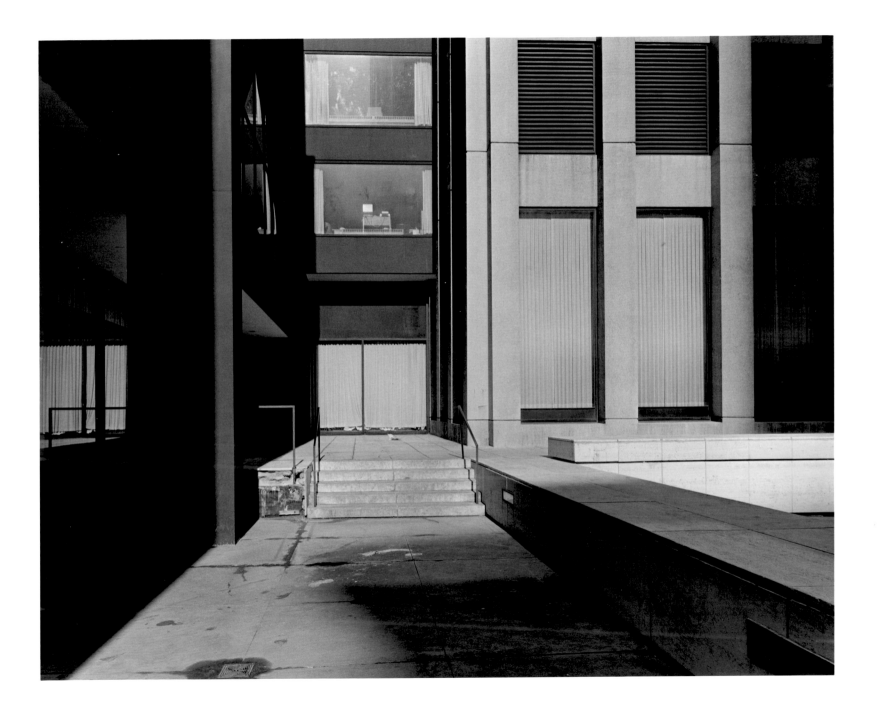

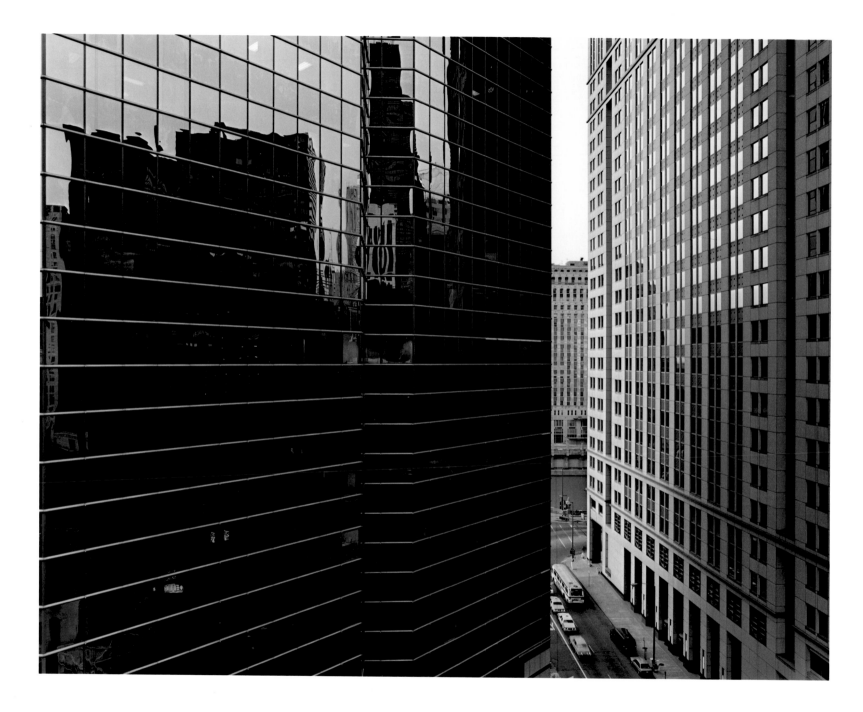

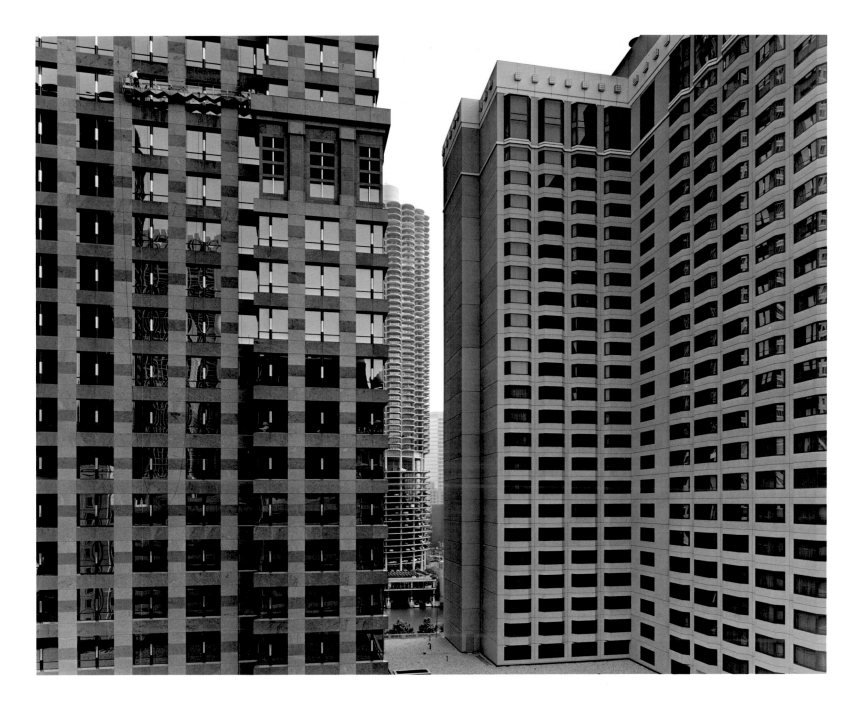

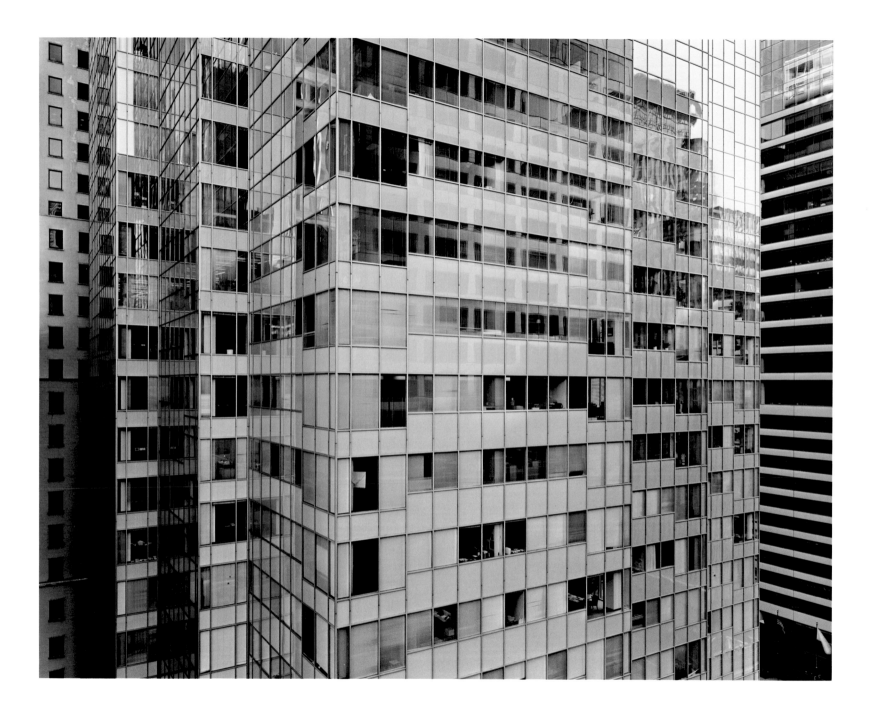

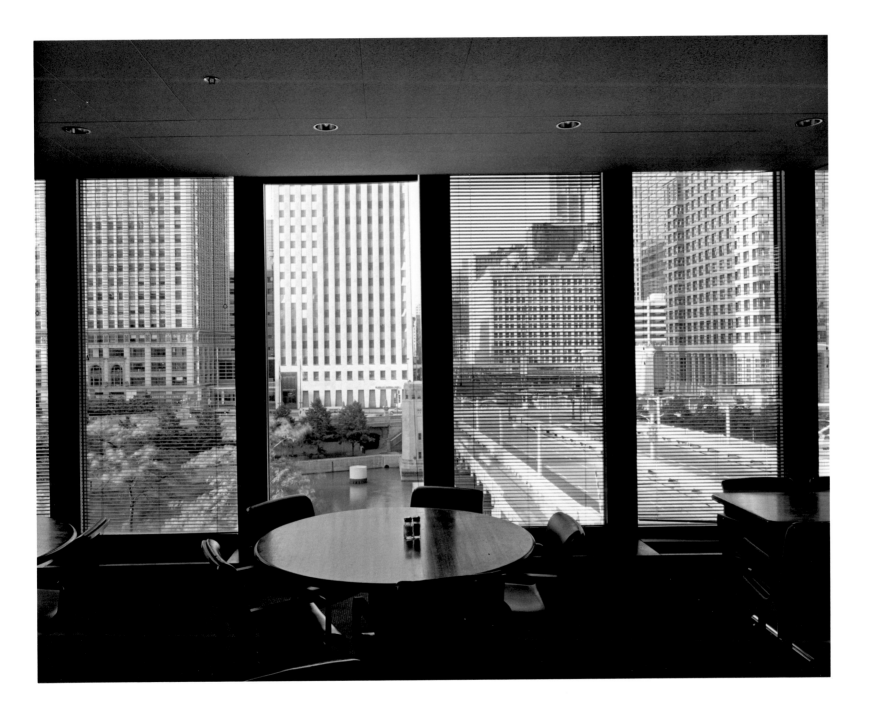

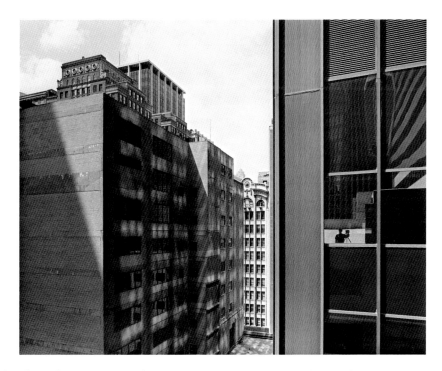

Any photographer who does descriptive work soon confronts questions about "documentary" photography. What obligation does the photographer have to be objective and truthful? How much of a situation needs to be described? What should documentary photographs look like? What effect, if any, should photographs have on the world they describe?

Lately, when I consider what photography should be, particularly documentary photography, I think of a room in the offices of the Chicago Commission on Architectural and Historic Landmarks. It holds examples of what some might consider perfect documentary photography. During the early 1980s several young interns began driving up and down each street in Chicago, rating the buildings according to age, historical and architectural interest, and original condition. About twelve thousand buildings passed the tests. An intern then stood directly in front of each landmark and took its picture. The photographs were made in unremarkable light, and the whole building was framed in the most sensible, predictable way. The prints were then mounted on cards with a site outline and a great deal of written information.

SELF-PORTRAIT, 1991

Researchers and scholars have found these photographs enormously useful, and the importance of this archive will increase with time.

I have two reactions to the Landmark Commission archive. First, I'm relieved that all of this work is done; the existence of good factual photographs frees me and others from the obligation to document particular buildings for purely historical reasons. Second, the photographs are perfect models of what most people think documentary photography should be: informative, objective, clear, encyclopedic, obsessive. I think it is instructive that once the needs of the investigator are met, the archive seems mute, devoid of interpretation or insight – devoid, it seems, of what is most essential to descriptive photographs.

When I see truly documentary photographs like these, or like pictures made for insurance purposes, I realize that the type of photography I hope to make is closer to literary nonfiction than to records and documents. I strive for a personal point of view, even if it is hidden behind a straightforward use of the medium.

I began to study photography at the University of Illinois at Chicago in 1968, while I was in the architecture program. I loved photography from the first class and soon changed majors. In the beginning I was attracted to the work of the photographers Henri Cartier-Bresson, Robert Frank, and Walker Evans. It seemed to me that one of the gifts photography offered was a motivation to explore and examine the world. For most photographers this might suggest travel to exotic locales, but I have always felt a sense of discovery and exploration in Chicago, where I have lived for forty-five years. Partly this is because of the nature of the city. In Chicago people cluster in groups, clearly delineated by race, ethnic origin, and income. Though that's true in most large American cities, in Chicago the divisions are extreme and finely drawn. The condition is reflected in many of the truisms one hears repeated: Chicago is a city of neighborhoods; Chicago is the most segregated city in the United States; Chicago is a city, says a psychologist I know, where if you know a person's high school and date of graduation, you know 90 percent of what that person is like.

Chicago is a huge city, roughly thirty miles long by ten miles wide. Until I started college I knew my own little neighborhood (Rogers Park), a strip along the lake, and the eastern part of

downtown. The rest of Chicago – the vast, flat, lake bed expanse of the city to the south and west – was totally unknown to me. It's not surprising that the places Saul Bellow describes in his novels seem rather foreign to me; his characters live on the South Side of Chicago, and I have lived my life on the North Side.

I started photographing the physical city in 1971. At first I concentrated on vernacular architecture in several residential neighborhoods: Pilsen, Bridgeport, and Uptown. I began photographing the central downtown area in 1972, and that soon became the main focus of my work.

Only recently have I realized how fortunate I was to stumble on such a rich endeavor. I was lucky because the everyday landscape is a fundamental issue in our lives, worthy of the closest attention. And I was lucky because to me Chicago is the paradigm of the modern American city.

Chicago was founded at the portage site between the Great Lakes and the rivers to the west, but topography was rarely acknowledged in the city's design. The rectangular grid system of streets derives from the federal land ordinances of 1785 and 1787 that divided unsettled parts of the Old Northwest (today's Middle West) to square-mile sections. Almost all Chicago streets run *exactly* north-south or east-west. Each mile from State and Madison streets there is a major avenue, with slightly less important thoroughfares at half-mile and quarter-mile intervals. There are several low ridges in Chicago (prehistoric beaches from a larger Lake Michigan), but generally the layout of the city is as flat and rational as a huge sheet of graph paper.

Lake Michigan and the Chicago River are certainly important topographical facts, but by 1830 early settlers had begun shaping the river and the lakeshore to conform to civic strategies. The river mouth was once near where the Art Institute now stands. The soldiers at Fort Dearborn cut a channel straight east through the sandbar to the lake. Later the entire river was straightened and simplified, and the flow was reversed. Rather than appearing to be a force of nature that prompted the founding of a great city, the Chicago River now has the aspect of a canal, designed as part of the city street system.

I often pass a charming little public beach house built in the 1920s. It's a good mile inland

from the lake. Of the thirty miles or so of lakefront, there isn't much that didn't begin with a clean sheet of white paper on some engineer's desk. Perhaps the first major alteration to the lakefront was in 1853, when Senator Stephen A. Douglas forced the Illinois Central Railroad to build its route into Chicago along the southern shore of the lake, some of which he happened to own. The railroad was obliged to erect trestles and breakwaters. The extension and shaping of the lakefront continued until 1964.

If the design of the city's landscape obliterated natural facts, it compensated by providing a good venue for commerce. The grid of streets proved especially conducive to the most exuberant real estate speculation. If you visit an old European city, the civic focal point – the best real estate – can be determined clearly and isn't likely to change. In Chicago it's important to be fairly close to the lake, but otherwise the center of the city is always open to change. In 1865 the focus of commercial activity in downtown Chicago was the corner of Lake and Clark streets. Potter Palmer bought cheap land several blocks away along State Street and built the city's most glamorous hotel. State and Madison then became the focal point. Similar shifts have occurred in the past ten years. Chicago is never meant to be finished; like any landscape, it is predicated on continuous, sweeping change. The city is big, energetic, thoughtless, crass – and proud of it. To me Chicago seems the perfect American city to photograph.

It is difficult to work with a view camera on crowded streets, so I often photograph Chicago at dawn or at sunset, when the business areas are almost deserted. Convenience was my first motive for working at these hours, but I soon became addicted to their particular qualities of light and to the quiet. These are moments when the city seems to lose its historical and social meanings and appears as a mysterious and dramatic organism. At 5:30 on a Sunday morning, downtown Chicago strikes me as like a small mountain range or a coral reef – a breathtaking fact of nature.

In making these photographs I intended to distill a certain kind of beauty. This beauty, I should point out, is not the scenic prettiness most travel books present. It is also not "livabili-

ty," a quality felt in smaller cities such as Chapel Hill, North Carolina, or Madison, Wisconsin. The beauty that interests me does not spring from discrete examples of good architectural design or enlightened urban planning: it's the subtle, unexpected, impractical beauty of a big city, made clear and accessible in photographs.

The photographs in this book provide only modest insight into the complicated forces that shape the physical landscape of Chicago or any city: economic cycles, zoning laws, political dramas, racial conflicts, the personalities of the movers and shakers. These forces operate too far beneath the surface for a topographical photograph to describe them. But the medium of photography is nonetheless very good at capturing and structuring visual epiphanies and a sense of place. Moments of light and space (beauty is perhaps the only word that can describe these small visual events) can be frozen and concentrated on four-by-five-inch sheets of film. Though they may seem trivial compared with the immediate problems of daily life, or even the complicated task of negotiating downtown streets, the medium effectively argues for the importance of these small visual occasions that, cumulatively, make a place a *place*.

My photographic interests have varied over the years, and the work in this book reflects a series of projects. One year, for example, I was particularly obsessed with radical changes of scale. Another year I tried to make photographs that described the course of demolition and construction. At times I was concerned with light, the unexpected play of scale, small open spaces within the city, the historical narrative incised on the surface of buildings, or the possibility of different picture structures for an urban landscape. These investigations were part of a larger attempt to distill the visual qualities of an archetypal American city. When I began to review, edit, and sequence these photographs I was confronted with a record of urban transformation, an evolution I could not have anticipated twenty-one years ago when I began the project. I decided to organize this set of photographs around that notion of *change*.

At one time I thought the beauty I found in the city's landscape derived from the nature of a great modern city – its size, energy, muscularity, and heedlessness. I thought this beauty existed *in spite of* the efforts and decisions of architects, planners, landscape architects, and de-

velopers, and I believed it would last forever. This was a very hopeful and innocent idea. My own work during the 1980s showed me I was wrong about the nature of the city, wrong to assume that its beauty is inevitable. The gigantic building boom that began in the late 1970s and lasted until the onslaught of deep recession in the late 1980s and early 1990s radically changed the landscape of downtown Chicago. The concentration of large buildings shifted westward and clustered along the river. The scale of buildings increased both in height and in "footprint." The materials and styles changed, eliminating much of the evidence of individual craftsmen. At street level the city became sanitized. Small eccentric businesses that lured pedestrians inside were replaced by large glass-walled lobbies and generic franchise stores. So much of Chicago's downtown has been rebuilt in a short period that the history of the city can no longer be deduced from the juxtaposition of buildings on each street. That change may hearten the city's leaders, but it has destroyed much of the visual quality that I and other Chicagoans loved most about this city.

The four-thousand photographs I have made of Chicago since 1972 are not intended to constitute the sort of objective archive that the landmark commission of any city likes to produce, but I am surprised and heartened to find some of that same historical value in this set of photographs. The depressed economy of the early 1990s has brought a lull in the radical changes to the urban landscape, a moment when we might stop to survey this great city and consider what has happened. The city that prompted me to begin photographing has now vanished, and so I am glad we have taken the time to pause and present this set of photographs in that great conservator of Western Civilization – the book.

# LIST OF PLATES

## ACKNOWLEDGMENTS

It has always seemed to me that the process of photography is not complete until the photograph has been published. Although for the past twenty years I have thought of these photographs of Chicago as a book in the making, I didn't begin to edit this work as a book until 1991, and even then the possibility of publication seemed remote. I am delighted that this project is now being produced, and I am indebted to many people who have been generous toward this work over all those years.

One of the first to see my book mock-up was Denise Miller-Clark, director of the Museum of Contemporary Photography at Columbia College Chicago. I would have been lost without her advice, her encouragement, and her magic Rolodex. Her first and most important contribution was to suggest that I show the project to George F. Thompson, president of the Center for American Places. I am enormously grateful to George; he has been an incisive, rigorous, enthusiastic, and patient editor. Even more important to me was his wonderful open-mindedness toward work that was totally new to him. Our first telephone conversation convinced me I had found someone who would understand this set of photographs. My colleagues and students in the Photography Department at Columbia College Chicago have been generous with interest in my work, criticism, and support. I especially want to thank my friend John Mulvany, chairperson of the Art and Photography Departments; Albert C. Gall, executive vice president and provost; and Dr. John B. Duff, president of Columbia College Chicago.

The publication of his book would not have been possible without the generous support of Columbia College Chicago; James J. Brennan of Brennan Steel, Northfield, Illinois; Lewis and Annie Kostiner of Annie Properties, Chicago; and Kimberly and Richard M. Ross, Jr. The Illinois Arts Council provided financial support for some of the photographs. Among the many people who helped edit and revise the sequence of photographs and my short epilogue were Valerie Hoffman and David Harris, associate curator, Photographs Collection, Canadian Centre for Architecture, Montreal.

A photographer working over time develops an audience. If one is lucky, this group of people offers willingness to look carefully, enthusiasm, encouragement, and rigorous criticism. From my first photography class I have been fortunate in finding my audience. A few of the people I want to thank are Peter Hales, Melissa Pinney, Marguerite Martino, Linda Robertson, and my friends and especially my early teachers at the University of Illinois, Chicago: Joseph Jachna, Hans Schal, and the late Robert Stiegler; David Travis, Nancy Hamel, Jack Jaffe, Phyllis Lambert, Richard Pare, David C. Rutenberg, Sonia Bloch, Edwynn Houk (in his Chicago incarnation), Stuart Baum, Carol Ehlers, and Shashi Caudill.  *Bob Thall*

Bob Thall was born, raised, and still lives in Chicago, Illinois, North America's third largest city. He received a B.A. and M.F.A. in photography from the University of Illinois at Chicago and has taught since 1976 at Columbia College Chicago, where he is currently professor of photography. His photographs have been exhibited widely across the United States and abroad, and they are part of numerous collections, including those of the Getty Center for the History of Art and the Humanities in Santa Clara, California, the Art Institute of Chicago, the Canadian Centre for Architecture in Montreal, the International Museum of Photography in Rochester, New York, the Library of Congress in Washington, D.C., the Museum of Contemporary Photography in Chicago, and the Museum of Modern Art in New York City. *The Perfect City* is based on photographs Bob Thall has made of downtown Chicago since 1972.

Peter Bacon Hales was born in Pasadena, California, and raised in Guilford, Connecticut. He received an A.B. in English and American literature, with honors, from Haverford College in Pennsylvania, and he earned an M.A. and a Ph.D. in American civilization at the University of Texas in Austin. In 1980 he joined the faculty of the University of Illinois at Chicago, where he is a professor and the director of graduate studies in the History of Art and Architecture Department. Among other works, Mr. Hales is the author of *Constructing the Fair: Charles Dudley Arnold and the World's Columbian Exposition* (1993), *William Henry Jackson and the Transformation of the American Landscape, 1843-1942* (1988), and *Silver Cities: The Photography of American Urbanization, 1839-1915*, for which he received a Merit Award from the American Society of Photohistorians. He has made his home in Philadelphia, New York, San Francisco, and Los Angeles; he lives today in Evanston, Illinois, less than a block north of Chicago.

The photographs in this book are part of an
exhibit, "The Perfect City," at the Art Institute of Chicago,
Autumn, 1994 (Photography Collection).

Books in the Series

*The Perfect City*, by Bob Thall

Designed by Glen Burris, set by the designer in Bodoni Book
with Syntax display, and printed on 100-lb. Lustro Dull Offset by
Becotte & Gershwin

Library of Congress Cataloging-in-Publication Data

Thall, Bob.
The perfect city / Bob Thall : with an essay by Peter Bacon Hales.
     p.   cm. – (Creating the North American landscape)
   ISBN 0-8018-4725-7 (alk. paper). – ISBN 0-8018-4726-5 (pbk. :
alk. paper)
    1. Architecture – Illinois – Chicago – Pictorial works.   2. Architec-
ture – United States – Pictorial works.   I. Hales, Peter B. (Peter
Bacon)   II. Title.   III. Series.
NA735.C4T48   1994
720'.9773'11 – dc20                          93-34460